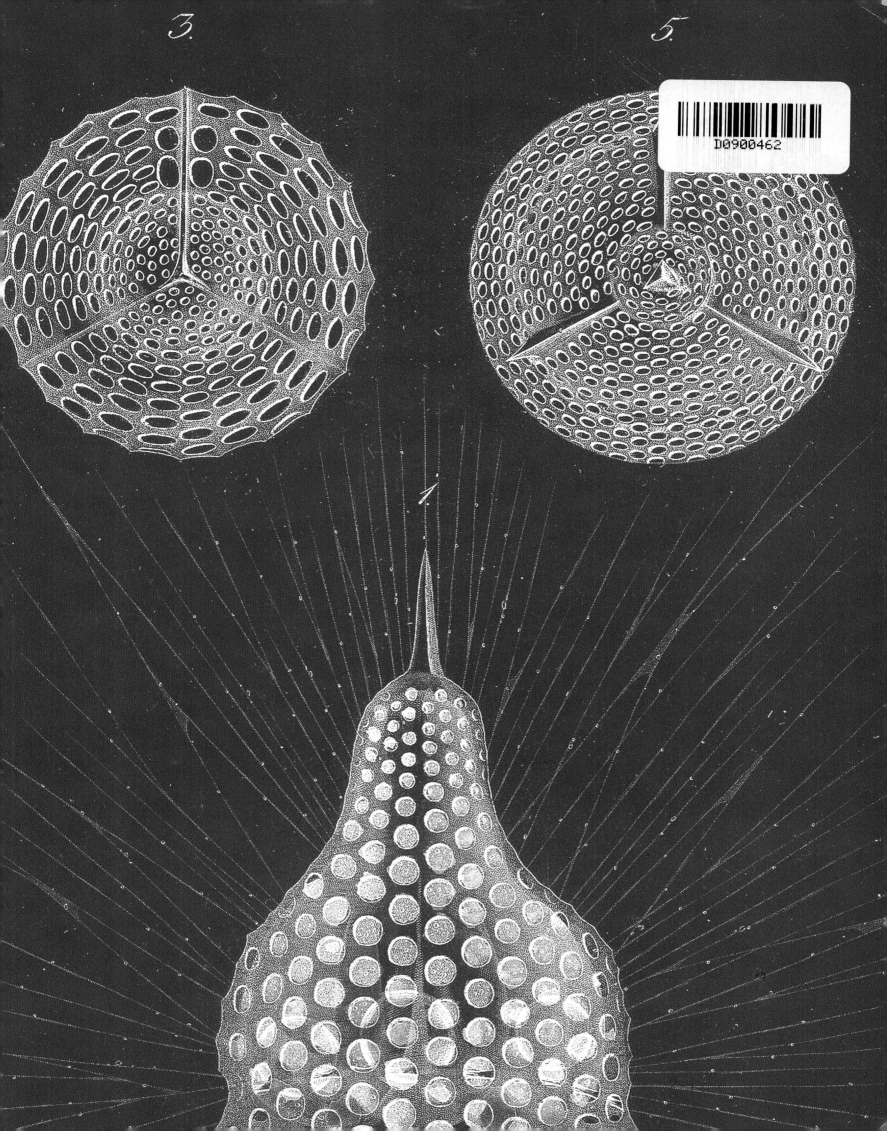

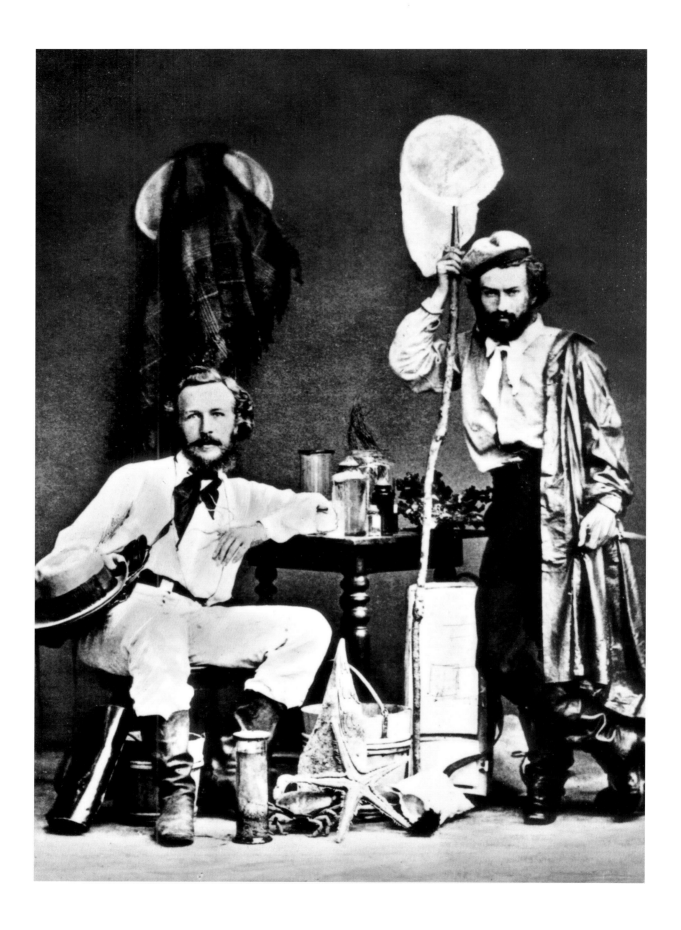

# ERNST HAECKEL

# Art Forms from the Ocean

*The Radiolarian Atlas of 1862*

*With an Introductory Essay by Olaf Breidbach*

## PRESTEL

Munich · Berlin · London · New York

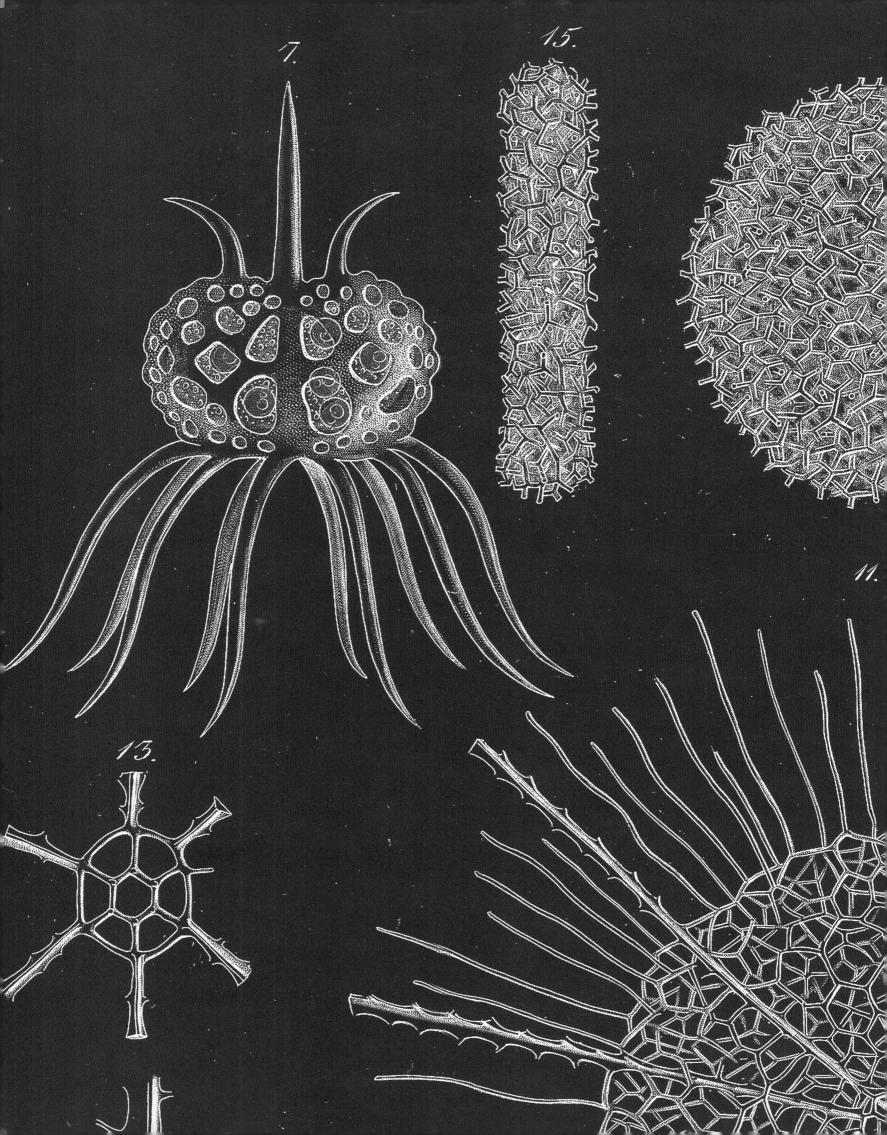

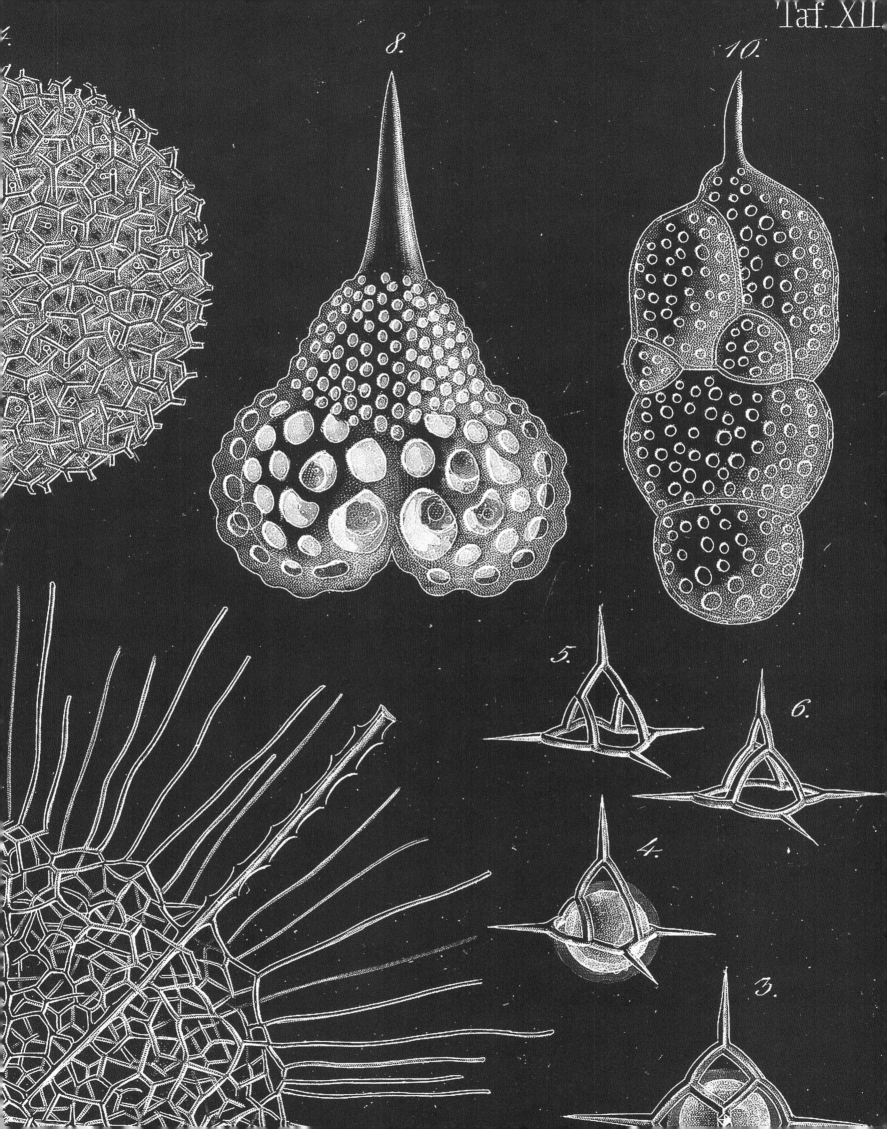

*Ernst Haeckel, photographed in 1867*

# The Most Charming Creatures

Haeckel's 1862 Monograph on Radiolarians

OLAF BREIDBACH, JENA

*The atlas of thirty-five plates
is the loveliest artistic achievement ever
in a scientific work on the lower animals.
I do not know what I should more admire
about it: Nature, which has created such
diversity and beauty of forms,
or the artist's hand, which has captured
such splendour on paper without tiring
in the execution of its hugely difficult task.*

Max Schultze in a letter to Ernst Haeckel,
21 October 1862

## I. RADIOLARIANS

Radiolarians are an ancient group of single-celled organisms that have existed since the Proterozoic eon in Precambrian time, the second oldest geological era in the formation of the Earth that ended around 570 million years ago, to be followed by the Palaeozoic era. Radiolarians are free-swimming protozoa that occur in all the world's oceans. They are microscopically small, with only some forms reaching a few millimetres in size. Although related to amoebas, unlike these simple single-celled animals, radiolarians frequently possess a spherical or helmet-like skeleton whose diversity of form fascinated the German zoologist Ernst Haeckel. For single-celled organisms, they have a complex cell body. We know today that some forms contain algal symbionts that provide most of their cell's energy, while other species capture micro-organisms by means of pseudopodia, filaments extended through apertures in their skeletons. More than 5,000 species are now known; even in Haeckel's lifetime several hundred had been described, although their behaviour and physical structure were unknown. Haeckel himself believed some forms to be fused metazoans (multi-cellular organisms) and classified them as animals on account of their motility.

## II. EARLY RADIOLARIAN RESEARCHERS

The Berlin naturalist Christan Gottfried Ehrenberg (1795–1876) was the first to describe radiolarians. He began his systematic microscopic analysis of plant and animal micro-organisms after 1820. From the 1850s onwards, the Berlin physiologist Johannes Müller (1801–58) also took a close interest in them.

Ernst Haeckel (1834–1919) was still a student at the University of Würzburg where he attended the lectures given by Rudolf Albert von Kölliker (1817–1905), Franz von Leydig (1821–1908) and Rudolf Ludwig Karl Virchow (1821–1902). In 1854, Haeckel again enrolled at the University of Berlin where, among others, he attended Johannes Müller's lectures on comparative anatomy and physiology. "Here," he noted in his diary in 1855, "for the first time, I became acquainted with a universally-acknowledged authority who I held to be an ideal scientist, just as his closer acquaintance (in the Museum etc.) for ever led me to my favourite science, that of comparative anatomy."[1]

One of the most distinguished German scientists of the first half of the nineteenth century, Johannes Peter Müller held the chair of Anatomy and Physiology at the University of Berlin from 1833. His *Handbuch der Physiologie des Menschen* (Elements of Physiology) set the trend for the development of modern thinking and working practices in physiology, yet he also made use of comparative morphology and was particularly interested in freeswimming microscopic marine life-forms. In an age when marine research stations were still unknown, he had gifted students accompany him on his field trips, usually to the French or Italian Riviera where he instructed them in the study of lower and microscopic marine animals.

In 1854, Ernst Haeckel spent the summer break on the North Sea island of Heligoland in the company of Johannes Müller, his son and a fellow student. Over a matter of weeks, Müller succeeded in filling Haeckel with enthusiasm at the prospect of studying marine life. A mere three weeks into their stay on the island, Haeckel wrote to his parents "that my decision is made: in future, I shall become a naturalist, a zoologist in fact, who investigates tropical shores."[2]

Müller also introduced Haeckel to the new collection techniques he had developed, such as the use of very fine gauze with which it was possible to catch plankton. Haeckel enthusiastically adopted this type of deep-sea fishing that had produced endless new material during his stay on Heligoland. Only a year later, however, Müller's passion for marine biology suffered a severe blow when a trip to the coast of Norway in the company of his students W. Schmidt and A. Schneider ended in tragedy. The boat carrying them back from Christiansand was shipwrecked. Müller and Schneider were able to swim to safety, but Schmidt drowned. As Haeckel wrote, "the long and awful struggle in the waves during that black night made an indelible impression on Müller. Since then, a deep and insuperable horror has taken the place of his particular fondness for the sea. He has never again able to entrust himself to that deceptive element, either aboard a slight barque or a solid steamship."[3] Müller's subsequent work on the radiolarians was thus rather limited.

*Johannes Müller (1801–58), Professor of Anatomy and Physiology at the University of Berlin, whom Haeckel much admired*

Müller coined the word 'radiolaria', and it was he who recognised "the true nature of radiolarians as rhizopods," i.e. that they are related to the amoebas. According to Müller, radiolarians were rhizopods without a contractile capsule; while some lack a skeleton, most possess one that is often spherical in shape. Classification of the radiolarians was thus possible according to the characteristics and composition of their skeleton.

### III. ERNST HAECKEL'S MONOGRAPH ON RADIOLARIANS

Haeckel dedicated his monograph on radiolarians to the memory of Johannes Müller whose views he shared. Applying his mentor's technique in the waters off Messina, Haeckel caught an abundance of live forms. He examined their structural characteristics and types of reaction to stimuli before analysing them systematically later in Berlin.

In his œuvre, Haeckel not only writes on the classification of this group of organisms as based largely on their skeletal structure; he also considers the questions of their sexual reproduction, growth, movement and distribution. Here he must still adwith to gaps in his knowledge, however. He certainly observes no "reaction to external stimuli that might be linked to sensation or consciousness in any radiolarian."[4]

*Six drawings made by Haeckel for his 'Monograph on Radiolarians'. From top left to bottom right: Arachnodictyon horridum, Haeckeliana porcellana, Arachnocorys circumtexta, Euchitonia Gegenbauri, Dictyopodium scaphopodium, Heliosphaera actinota.*

Haeckel commented very little on the internal structure of the radiolarians. This was due, he himself explained, to the problems associated with observing live specimens and the difficulty of fixing their soft anatomy. Thorough examination of the structure of the cell body was thus made more difficult. Haeckel described the nucleus and its characteristics, but did not recognise the nucleus for what it was. This explains his lack of certainty that radiolarians are single-celled organisms. It was not until 1879 that his student Richard Hertwig (1850–1937) was finally able to confirm that they do indeed belong to the Protista, the kingdom of predominantly single-celled microscopic organisms.

Haeckel additionally described inclusions in the cytoplasm that we now know to be algal symbionts, but he himself was unaware of this. He was able, however, to give an accurate description of the highly diverse radiolarian skeletons that support the complex cell material. Where that material had become detached or where deposits of dead animals occurred, skeletons were readily available to him for microscopic examination. The skeleton itself was relatively easy to preserve and store for subsequent examination, unlike the live cell body which could not be fixed satisfactorily. For these practical reasons alone, Haeckel's classification of radiolarians refers essentially to analyses of skeletal structures, based on which he attempted to illustrate how the radiolarians are related.

*Classification table of the families, sub-families and genera of radiolarians, in: Ernst Haeckel, 'Die Radiolarien (Rhizopoda radiaria). Eine Monographie', Berlin 1862*

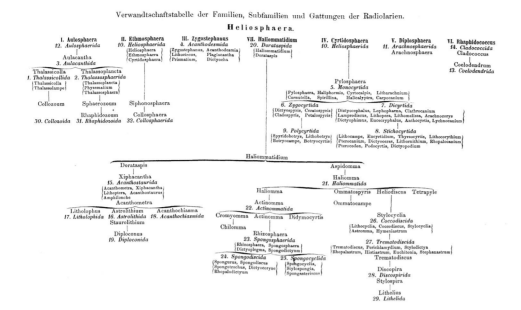

Haeckel's classification scheme remains fundamental to radiolarian research to this day. His illustrations are still one of the most important sources of popular and specialist depictions of this group of animals. Besides the descriptions of deep-sea radiolarians that V. Haecker presented in the report of the *Valdivia* expedition, Meyer's *Enzyklopädisches Lexikon* from 1978 cites only Haeckel's 1862 *Monograph on Radiolarians* as further reading on the subject. In 1973, K.G. Grell's *Protozoology* – still *the* standard text for taxonomists – cited only four other original publications as further reading on radiolarians besides Haeckel's monograph and his paper from the H. M. S. *Challenger* expedition. Haeckel's *Monograph on Radiolarians* is thus a benchmark, one that to this day is fundamental to studies of this group of animals.

Yet in his monograph, which was very warmly received at the time, Haeckel ventured beyond a narrow illustration of the systematisation of a selected group of organisms. In one of its notes – using somewhat qualified language – Haeckel declares his cautious yet wholehearted support for Charles Darwin.

Darwin's epoch-making treatise *On the Origin of Species* was published at the end of 1859. It came to Haeckel's attention in the summer of 1860 just after it appeared in Bronn's annotated translation.[5] According to Darwin, species diversity was the result of a process of evolution, not the result of an act of divine creation. This implied that different forms were linked by genealogy. Classification of forms was therefore an expression of true evolu-

tionary relationships in whose course diversity of form arose from variations that can be observed in the production of offspring and a process of natural selection in which improved forms were able to assert themselves over less improved ones and thus able to reproduce. Darwin illustrates the concept in his treatise by using the example of new breeds of domesticated animals. Here, too, chance combinations of characteristics are selected by the breeder so as to stabilise new varieties; in this way new breeds can develop. Darwin viewed the process of formation in nature in a similar fashion, although his difficulty was that he was still unaware of the mechanism of inheritance, through which species characteristics are retained over successive generations. Genetics was still unknown to Darwin's evolutionary biology that, for the time being, was purely a descriptive theory.

Haeckel now adopted Darwin's approach of regarding diversity of form as the result of a genuine process of creation. Classic systematisation now acquired a new meaning for him, without the need to develop new methods of comparative anatomy that would allow him to regard the variety of forms as having developed as part of an evolutionary process. In this respect, his practical work as a naturalist shows him to be in keeping with traditional methods and scientific investigation at the end of the eighteenth century. Haeckel modernised this conventional view of natural history solely by adapting Darwin's programme in which the orders of life forms as formerly constructed acquired a new and ground-breaking significance for him. Similarities in the structure of individual groups of forms were no longer coincidental; instead they pointed to a shared history. Seen from this viewpoint, the concept of a natural system for radiolarians acquires a significance that goes far beyond the intentions of the botanists who succeeded Carl Linné (1707–78), who was the first to proclaim such a system:

"I cannot help but take this opportunity to express the great admiration that Darwin's intellectually stimulating theory on the origin of species arouses in me," Haeckel wrote. […] "It is Darwin's hope that his theory be tested by 'young and rising naturalists able to view both sides of the question with impartiality. Whoever is led to believe that species are mutable will do good service by conscientiously expressing his conviction; for only thus can the load of prejudice by which this subject is overwhelmed be removed.' I share this view wholeheartedly and believe I must here express my belief in the mutability of species and in lines of descent in all organisms. While I have reservations about sharing every one of Darwin's views and hypotheses and about believing him to be right in every point of his reasoning, I must admire his work as the first serious scientific attempt to explain all the manifestations of organic nature from the one mavellous, unified point of view and to replace incomprehensible wonders with comprehensible natural law."[6]

Ernst Heinrich Philipp August Haeckel was born on 16 February 1834 in Potsdam and grew up in Merseburg. At the age of eighteen he began to read medicine and science. His university career started in Berlin where his parents had moved to following his father's retirement. In the autumn of 1852, Haeckel left Berlin to study at the University of Würzburg, drawn to its Faculty of Medicine in particular by the work of the analytical chemist Johann Joseph von Scherer, the histologist Albert von Koelliker and the pathologist Rudolf Virchow. Haeckel started to study medicine at his father's wish, but he was not drawn to its core subjects on account of his loathing of disease. "I view anatomy purely from the viewpoint of the natural history of man – not a medical one! As such it may perhaps come in useful for me later in my studies of mathematics and science."[7] Besides an introduction to anthropogeny given by Franz von Leydig – then still an independent lecturer at Würzburg – lectures by Kölliker on comparative anatomy and human physiology were crucial for Haeckel, although lectures on the Infusoria, single-celled organisms, also made a lasting impression on him. He furthered his studies of histology and anatomy under Kölliker and in a lecture series on pathological anatomy given by Virchow, who around this very time was developing his theory of cellular pathology. It postulates that the cell is an organic functional unity; accordingly, diseases arise due to dysfunctional cell processes that are to be identified by histopathologists.

Cell anatomy fascinated Haeckel, but at the suggestion of friends, he returned to the University of Berlin in the summer term of 1854. Among the lectures he attended were those on mineralogy given by Christian Samuel Weiss (1780–1856), the discoverer of crystal symmetry. Yet it was the lectures of Johannes Müller that were to have a lasting influence on Haeckel whose first publication was the result of a joint field trip to Heligoland.[8]

Having passed his *tentamen philosphicum* at the end of 1854 (it was replaced by the *examen physicum* after 1863), Haeckel returned to Würzburg for three semesters to continue his clinical training at the Julius-Spital. While there, he made a point of attending the lectures of Rudolf Virchow, who soon spotted his talent and encouraged him to prepare some unusual cases for his demonstration course and to publish his findings in the Viennese *Medizinische Wochenzeitschrift*. On 23 April 1856, Haeckel was hired as Virchow's assistant although he was working on a topic – the histology of the freshwater crayfish – that Kölliker had set for his dissertation and that he was to complete in Berlin in 1857. Haeckel then went to Vienna where he attended lectures by the physiologists Ernst von Brücke (1819–92) and Carl Ludwig (1816–95). He returned to Berlin in August 1857 to sit his state

medical examination. Haeckel was licensed to practice as a general practitioner in Berlin on 17 March 1858, but opened a practice in name only. Under the guidance of Johannes Müller, Haeckel wanted to pursue his comparative studies of microscopic anatomy, but Müller's sudden death on 28 April 1858 thwarted his plans.

Haeckel knew Carl Gegenbaur (1826–1903) from Würzburg where he was an independent lecturer. In 1855, he was called to Jena as Associate Professor of Zoology and Comparative Anatomy; in 1858 he was appointed Chair of Anatomy. Gegenbaur invited Haeckel to Jena in March 1858 and encouraged him to join him on an expedition to Messina. On the occasion of celebrations to mark the University's tercentenary, Haeckel returned to Jena. In a confidential discussion with Gegenbaur and the University curator, Karl Julius Moritz Seebeck (1805–84), he was offered the certain prospect of a future lectureship at Jena. As Gegenbaur was unable to go on the expedition, Haeckel had to set off to Messina alone. His father agreed to pay for the trip.

## V. HAECKEL IN ITALY

Following intensive preparations, Haeckel left Jena on 28 January 1859 and travelled by way of Halle and Würzburg first to Genoa, then to Florence and Rome. In Florence he acquired a powerful microscope in the workshop of the renowned physicist and microscope maker Giovanni Battista Amici. With its water immersion lens, it permitted a magnification up to 1,000 times. Haeckel then spent almost five weeks in Rome to enjoy its history and art before travelling on to Naples at the end of March to start his scientific research. He had, however, chosen a bad time of year. His original topic, the anatomy of echinoderm such as starfish and sea urchins – suggested to him by Johannes Müller – proved to be impracticable, as he was unable to procure suitable subjects. In despair, Haeckel turned to the delightful Italian countryside around him. Just before setting off on a week's trip to Ischia, he happened by chance to meet the artist Hermann Allmers (1821–1902). "Through him, my own enthusiasm for drawing really was rekindled. It is largely him I have to thank for enabling me to draw everything with twice as much freshness and accuracy. I had no peace until all the landscapes that had become so dear to me were captured in my sketchbook. Indeed in Messina, at the end of our wanderings together, such was his influence that I was on the point of changing direction altogether, of abandoning natural science as my main subject in favour of becoming a landscape painter."[9] When Haeckel was still drawing and studying plants on Capri in August, his father put him firmly in his place.

*Ernst Haeckel's microscope*

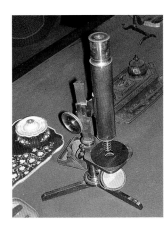

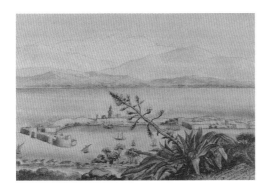 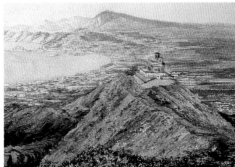

*Watercolours by Ernst Haeckel:*
*(far left) Messina, the harbour and Aspromonte,*
*viewed from the Villa Guelfonia, 1897*
*(left) Naples, a view from the observatory on*
*Vesuvius, 1859*

Haeckel and Allmers went their separate ways on 17 October 1859. A new phase in Haeckel's trip began, one that would be crucial for his scientific work. He spent six months doing systematic research on the marine plankton in the Strait of Messina, a place noted for its wealth of lower animals. When Haeckel discovered some undescribed species of radiolarians, he selected these for special treatment. He now had a fruitful topic. Before leaving Sicily, he succeeded in identifying 120 new species of radiolarian. When he left Messina on 1 April, he had twelve crates of material with him. The return journey took him via Marseille and Paris back to Berlin where he began to evaluate his findings and examine the material he had collected. At the same time, he contacted Gegenbaur who again tried to lure Haeckel to Jena. Gegenbaur urged Haeckel to habilitate during the winter term of 1860 /61 and to begin lecturing immediately so as to forestall other applicants for a possible post in zoology at Jena. Haeckel felt unable to complete his large monograph on the radiolarians in such a short time, however. Nevertheless, he was able to present his preliminary findings on 17 September 1860 at the thirty-fifth congress of the Society of German Naturalists and Physicians in Königsberg.

### VI. FROM RADIOLARIANS TO A PROFESSORSHIP IN JENA

Only a short while later, two other possible careers presented themselves. Haeckel had prospects at Hamburg Grammar School and at the Academy of Arts in Berlin as Professor of Anatomy. He withdrew that application after only three weeks, however, when it became apparent that he was being implicated in an intrigue. Once the Medical Faculty of the University of Jena, under its dean Matthias Jacob Schleiden (1804–81), co-founder of the cell theory, and the University's benefactors had approved Haeckel's application to habilitate as an independent lecturer for comparative anatomy, he moved to Jena on 24 February 1861. He habilitated on 4 March with a sixteen-page paper that considered the boundaries and orders of the rhizopod;

it effectively became Chapter iv of his *Monograph on Radiolarians* that was published a year later. Haeckel concluded his habilitation process on 5 March; the subject of his probationary lecture was 'The Vascular System in Invertebrates' (*Über das Gefäßsystem der Wirbellosen*).

With nine students in his class, Haeckel began his career as a lecturer in zoology on 24 April, and he gave a further series of lectures over the following winter semester. The rest of the time he spent completing his monograph; after all, his promotion to the post of associate professor depended on its publication. Given delays at Georg Reimer's printing works in Berlin, Haeckel had four copies of the first general part of his monograph bound separately and had them sent to influential figures. His ploy worked: on 3 June 1862, Haeckel – now aged twenty-eight – was appointed associate Professor of Zoology. He was now able to relieve Gegenbaur who held a full professorship in the faculty of zoology. Two days later, Haeckel was additionally appointed to the post of Director of the Grand Ducal Zoological Museum.

Later that year, the *Monograph on Radiolarians* was published in conjunction with an atlas of thirty-five plates executed by the Berlin copperplate engraver Wagenschieber. The monograph quickly received widespread attention. Leading naturalists such as Leuckart (1822–98), Franz von Leydig or Darwin's most fervent English supporter Thomas Henry Huxley (1825–95) publicly expressed their admiration and recognition. On the strength of his achievement, Haeckel was admitted to the Leopold-Caroline Academy of German Scientists on 20 December 1863. Only two months later, at the suggestion of its president, Carl Gustav Carus (1789–1869), he was presented with the institution's highest award, the gold Cothenius Medal. Haeckel, who went on to champion Darwinism, had finally succeeded as a zoologist.

## VII. HAECKEL'S ACTIVITIES AFTER 1862

There follows an outline of the remainder of Haeckel's life. Following the terribly premature death of his first wife Anna, Haeckel threw himself into his work in 1864. In the space of only two years, he produced his two-volumed *Generelle Morphologie der Organismen* (General Morphology of Organisms). Published in 1866, it contained detailed phylogenetic trees of all organisms, including man. Taking his work on the radiolarians as his starting point, Haeckel developed the idea that the evolution of the blueprints of the different species ought to be understood as the gradual development of increasingly complex symmetrical relations. In this way he developed a kind of 'organic crystallography'. Gradual differentiation in symmetrical relations would give rise to the pattern according to which organic generic types may

have evolved. Haeckel thus took the offensive in his support for a new biological canon written according to the principles of Darwinism.

In 1867, Haeckel married Agnes Huschke. In 1868, he published his popular *Natürliche Schöpfungsgeschichte* (The History of Natural Creation) whose German version alone went through twelve editions between then and 1920. In it are collected "universally comprehensible scientific lectures on the theory of evolution in general, and those by Darwin, Goethe and Lamarck in particular, on the application of the same to the origins of man and other related fundamental questions of science." Haeckel's work contributed significantly to the popularisation of Darwin's theories. In 1874, he published his monograph on the calcareous sponges in which he presented his concept of 'biogenetic law' which postulated 'ontogeny recapitulates phylogeny', i.e. that the stages of development, especially of the embryo, reflect the evolutionary history of the organism. Two years later, he published his popular *Anthropogenie oder Entwickelungsgeschichte des Menschen* (Anthropogeny or the History of the Development of Mankind).

Haeckel recognised very early on that his demand for a comprehensively biological interpretation of post-Darwinist thinking could not be realised within an academic framework. As a result, he began to write for the wider public. To complement his own efforts at popularisation, after 1880 he created his own circle of admirers whose most important figures were Wilhelm Bölsche (1861–1939), Carus Sterne (1839–1903) and Wilhelm Breitenbach (1856–1937). These men each wrote for the different social classes with their particular interests in biology. Around 1900, Haeckel thus practically enjoyed a monopoly in the popularisation of Darwinism in German-speaking countries. As the Prussian government had banned Darwinism from the school curriculum, anyone interested in its postulations and subsequent consequences could hardly avoid the writings of Haeckel and his associates.

In Haeckel's view, therefore, biology was no ordinary specialist discipline. Starting with his views of a comprehensive reorientation of thinking in the spirit of Darwinism, Haeckel devised a scientific 'religion' with a biological foundation. He developed the idea in *Welträthsel* (Enigmas of the World) which he published in 1899. Around the turn of the century, this book made him one of the most famous German naturalists. In it, he preached a biologism that, on the one hand, was formulated as a philosophical theory, yet on the other hand was also based on aesthetics. Between 1899 and 1904, Haeckel published his *Kunstformen der Natur* (Art Forms in Nature) which contained striking plates that had a significant influence on the culture of the day.[10] He described a natural world in which all forms are presented as the ornaments of a universal design framework.

*Polyaxonal and homopolic organic forms, in: 'Ernst Haeckel, A general morphology of organisms. Common elementary features in the science of organic forms and mechanisms based on Charles Darwin's reformed theory of descendance. vol. 1: 'A General Anatomy of Organisms', Berlin 1866*

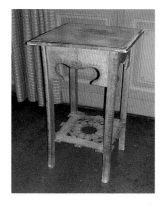

*Plant stand, Haeckel-Haus,
Jena, with radiolarian motifs
from drawings made by Ernst
Haeckel*

Haeckel viewed nature through the eyes of his age and adapted his 'objective' illustrations to the perceptual paradigms of the day. His own perceptual paradigms were already partly formed by *Jugendstil* (the Art Deco style in Germany) and were readily converted into this new style of formal design. The nature of his deep-sea organisms was such that they, too, could be adapted into ornamental Art Deco figures. Artists like René Binet (1806–1911), the architect of the Paris World Fair, translated the natural forms as revealed by Haeckel into art forms. The gateway to the Paris World Fair in 1900 mirrored the form of one of Haeckel's radiolarians enlarged to gigantic proportions. The effect of such a visual programme was widespread; it made it very clear that the design of that time corresponded to the perception of nature.

Such an appropriate view of nature was broadly received. The idea of a gradual unfolding of forms – including intellectual ones – led to developments in the origins of the evolutionary theory of art in which Haeckel was of central significance. The vividness of the natural as represented in such paradigms and its cultivation in visual paradigms continued to have an effect beyond Haeckel's death in 1919. Confronted with a vast diversity of forms that bearly appeared to permit any structural definition, the idea that it was possible to grasp nature intuitively was suspicious for biologists.

This had consequences for the presentation of natural history as a whole. According to the Haeckelian view, it was now sufficient to construct a correct image of nature. Even if it was aestheticized, nature was conceived *as* nature because the conception of order used was that of evolutionary

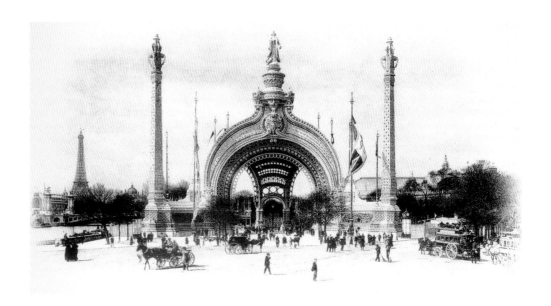

*René Binet's gateway to the
Paris World Fair in 1900,
inspired by Haeckel's drawings
of radiolarians*

biology. Nature reveals itself it its forms and reveals itself as natural in the order of its forms. This order is that of a historical process. Accordingly for Haeckel, all symmetries, systematisations and classifications were proof of evolution especially when they could be depicted in nature. Evolution and, with it, the very existence of nature and, by implication, nature itself, were for Haeckel depicted in the laws of nature. Thus for Haeckel, to know is not to conceptualize but to see. What nature is, is visible on its surface. The plastic form that this visibility of nature assumes is therefore more than the illustration of a text. It bears within itself the knowledge that the text then merely explicates.

The natural history films that still characterised German television culture in the 1960s developed precisely from this view. Consequently, the image of nature is its truth. Nature is not an abstract mechanism, but what this mechanism brings to light, which then appears to have been explained once order has been found in it. A beautiful, plastic image conveys a natural truth even in the simple case of an illustration that reproduces a symmetrical pattern.

The metaphor, used by the young Haeckel to characterise his work to his beloved fiancée, is fitting. While working at Messina, he wrote to her on 16 February 1860: "The happiest day probably in my scientific career [she will have heaved a sigh of relief], the happiest day of my whole life, was the tenth of February when I set out early as ever with my fine net to fish, and I caught no less than 12 (twelve!!) new species [radiolarians]; the most charming creatures were among them! A lucky catch that made me half demented with joy. I knelt down in front of my microscope and cried my heartfelt thanks to the blue sea and the generous sea-maidens, the fair Nereids, who always bestow on me such glorious gifts. I promised to be good and decent, worthy of such fortune, and to dedicate my whole life to the service of glorious nature, truth and freedom."[11]

This metaphor also fittingly characterises Haeckel's later occupation with nature. For him, nature is a reference point, a standard and thus, in itself, in that which is visible of it, the truth. This is by no means a later idealisation of Haeckel, the populist. It is his inner conviction from whence he comprehended nature. For him, nature is what he can experience, what is visible of it. A scientist can comprehend the visible and only then can he reproduce it. If he does so and recognises the regularities in what is visible to him, he can conceptualise the experiences that nature affords him.

Haeckel was a natural scientist while, at the same time and in a more profound sense, he was also an artist. It is not simply a case of grasping the law that can be derived from possible changes in something that one experiences. Rather the individual empirical image of a natural whole – that is to be depicted in singular unities – has to be grasped. Here in fact we find an

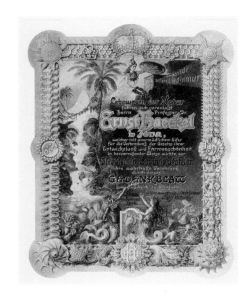

*An encomium presented to Ernst Haeckel on turning seventy, which states: 'All natural living creatures feel bound to express their unreserved admiration of Professor Ernst Haeckel of Jena – who has championed the laws of their development and the beauty of their form in such an exceptional manner and with such tireless enthusiasm – on the occasion of his seventieth birthday as symbolized by this commemorative certificate. Jena, 16 February 1904. Adolf Giltsch, Secretary.'*

affinity with Goethe who also understood that the self-sufficient, true greatness of the natural world lies in nature's form rather than in the abstraction of laws.

Before becoming the main proponent of Darwinism in Germany, Haeckel started his career as a comparative morphologist; he searched for, drew and described the forms of animals. He drew upon the wealth of the sea, illustrating and documenting its contents, and praised God's creation. God, however, changed in the eyes of this lover of nature who had been raised in a deeply religious but liberal family influenced by the thinking of Schleiermacher. As he wrote to his beloved cousin and future wife, he fell to his knees before divine Nature that was revealed to him particularly through research in the natural sciences. This revolutionary spirit thus started off in a tradition thoroughly shaped by religion. Trained at Würzburg under the leading morphologists of his day, Kölliker and Virchow – with whom he never developed a personal relationship, however, despite his great admiration for them as scientists – and above all influenced by the great physiologist Johannes Müller, Haeckel strikes us as a latter-day eighteenth-century naturalist in his letters and work. He records the variety of forms he finds in organisms, he describes their skeletons, soft anatomy, habitats and habits, and he arranges systematically, his methods akin to those of the great botanist Johannes Hedwig (1730–99) before 1800 and the Italian Antonio Vallisneri (1661–1730) in the early eighteenth century. Haeckel's drawings are smaller, however, and he works with a microscope, discovers a wealth of forms in the smallest organisms and thus experiences the detail of a new universe whose discovery inspires a sense of reverence in him – despite its microscopic size.

This goes towards explaining why his illustrations are so precious. They show the very forms before which Haeckel fell to his knees in 1860. These are not merely forms that he discovers and can adapt to what he already knows. He experiences interrelations between these forms; for him, they represent orders and a natural process which is visible in them. He draws small wonders of nature in which nature itself is recreated. It is his very own, newly discovered world that he is imagining and trying to show in these illustrations.

By way of thanks for all their support, Haeckel sent his parents – not the text of his treatise, the literary essence of his scientific studies – but his illustrations that contain the real message of his publication. For Haeckel, nature has been captured in these illustrations. The pictorial cosmos he

*Plate XXXI: Cyrtoidea, taken from Haeckel's 'Art Forms in Nature', Leipzig 1899–1904*

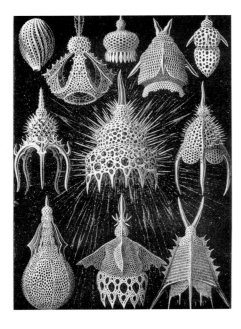

produced – comprising proofs, first impressions and original drawings – he gave to his parents as a present.

Haeckel's book contains more than mere row upon row of forms. Each plate is a tableau in which Haeckel neatly arranges – in fan shape – variations of individual forms. In each fan, nature's playful forms are distilled into series of similar designs. Progressions of form reflect a system and, in this way, Haeckel obtains a 'natural system' for the radiolarians. These plates show what, where and how variation occurs. Thus a formal canon is deciphered that brings order to the undefined forms collected in a plankton net. This order is the order of crystalline structures.

Haeckel, who also studied under the mineralogist Christian Samuel Weiss – his exam on Weiss's subject was the only one in which Haeckel did badly – represents the structure of formal variations of organic crystals. Haeckel is aware of this as he knows that his systematisation is based essentially on the architectures of the skeletons of the organisms he examined. Initially, there were practical reasons for this, but it did greatly simplify his task of tracing occurrences of symmetry in different organisms – after all, as has already been mentioned, the skeleton of these organisms was easier to examine in more detail. Haeckel still regarded these forms as animals whose bodies had been created by the fusion of tissue. While he mentions the criterion selected by Kölliker for the identification of single-celled organisms – the presence of one nucleus only – he does not give a clear description of the internal structure of the forms that under microscopic observation are revealed to be highly delicate.

In 1870, G. Fritsch and O. Müller edited a volume called *Die Sculptur und die feineren Strukturverhältnisse der Diatomaceen*[12]. It contained a large-format series of microphotographs of the shells of diatoms and presented photographs of a diatom specimen. The first image, not considerably enlarged, shows a slide preparation of diatom shells. This is followed by single, large-format images of diatom shells laid side by side on the glass slide. The delicate shells of diatoms were also used, among other things, to test the resolving power of microscope lenses. Only very powerful microscopes were capable of showing the delicate markings found on diatom shells. The illustrations in this volume merely show natural decoration and take their place in traditional eighteenth-century perceptions of nature, albeit employing the new technology of microphotography. This is a photography book that documents nothing less than the structure of a preparation. It shows juxtaposed forms, arranged in rows according to similarity and symmetrical structure. These are illustrations of natural decoration, not some scheme of classification, yet their aesthetic quality matches that in Haeckel's visual paradigms. Conversely, Haeckel's plates are thus part of the visual tradition of photographic plates refering back to eighteenth-century

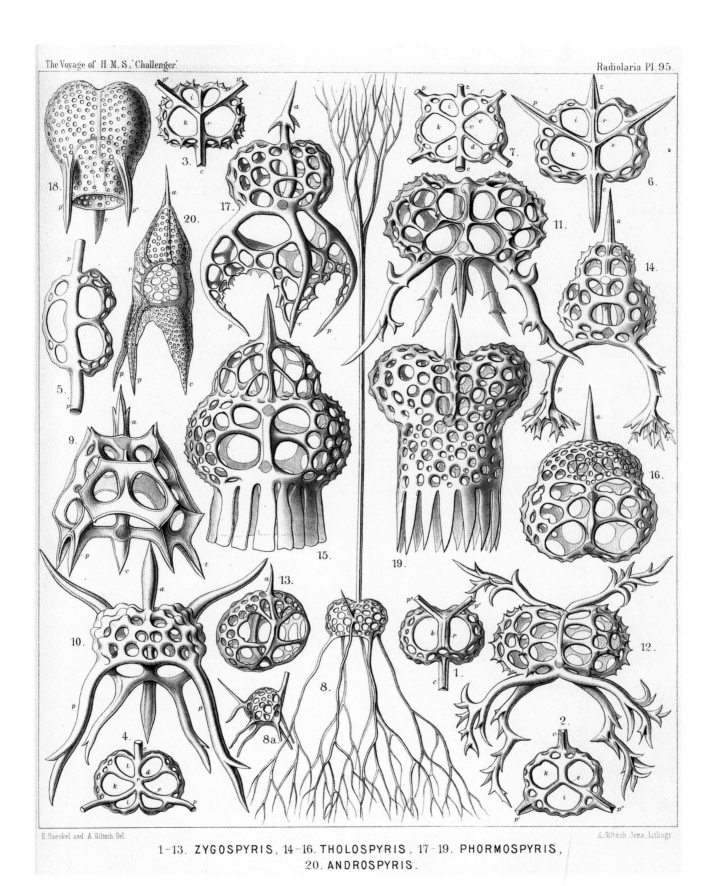

E.Haeckel and A.Giltsch Del.

A.Giltsch, Jena, Lithogr.

**1–13. ZYGOSPYRIS, 14–16. THOLOSPYRIS, 17–19. PHORMOSPYRIS,
20. ANDROSPYRIS.**

*Radiolarians: Spumellaria and Nassellaria,
plate XCV, from the Challenger Radiolarians*

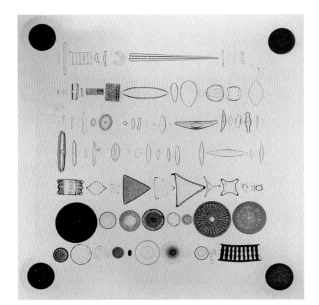

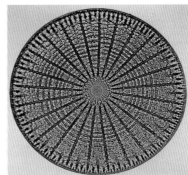

*Gustav Fritsch and Otto Müller, 'The sculptural shapes and intricate structural relationships of diatomaceae based on species used in experiments.' Department 1, 12 plates of micro-photographic illustrations. Berlin 1870*
*Plate 1: Diatomaceae kinds, pl. 11 by J.D. Möller of Wedel*
*Plate 11 : Arachnodiscus ornatus. Ehrbg.*

perception and presentation. Similar images were available only to courtiers and other wealthy individuals who could afford microscopes, although in the meantime within the framework of science, natural science had become available to all classes of society. This new knowledge for the academic elite was now to be found as a decorative element at court in depictions of nature. In this respect, it is only consistent that such natural forms re-appear in architectural designs and the design of items of everyday use.

Thus it is that the very forms illustrated by Haeckel soon became forms of art, something that he deliberately encouraged, as exemplified by the decoration found on a dining table presented to him on his sixtieth birthday. As a contemporary certificate reveals, if all of nature's creatures were to congratulate Haeckel on the occasion of his sixtieth birthday, then the radiolarians also had to be present. For his seventieth birthday, Haeckel was presented with a bronze plaque in which Nature offers up her bounty to the scholar. The deity found by Haeckel amid such treasure is cast in the form of the Nereids.

Haeckel's *Monograph on Radiolarians* was not the only systematic study in his career as a research scientist. He was not only a militant Darwinist and biological philosopher; as a scientist, he was above all a taxonomist and a systematist. In a comprehensive analysis, he described a wealth of different groups of marine animals. In 1872, his monograph on the calcareous sponges appeared; in 1879 and 1880, he published his *System of the Medusæ*. In 1887, the second part of his *Monograph on Radiolarians* in which he presented an outline of the natural history of this group of animals was released. Finally, for the expedition of *H. M. S. Challenger*, Haeckel edited the

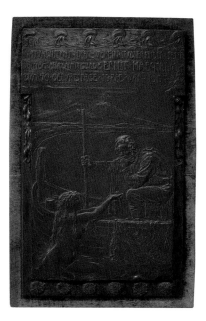

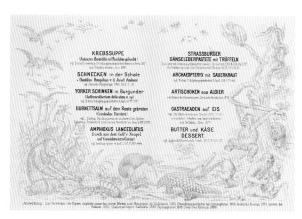

data on the medusæ, siphonophores and, of course, the radiolarians. The diversity of forms that he assembled, identified, described and systematised is immeasurable. The scheme of classification he devised pointed to the future. It is omnipresent and relevant to this day, not only in his exquisite illustrations, but also in his order of classification.

Haeckel's 1862 *Monograph on Radiolarians* initiated a long series of publications in which a naturalist attempted to make nature visible and to comprehend nature by means of his illustrations. Throughout his life, Heckel remained true to the oath that he swore to the Nereids in the Strait of Messina in 1860.

1  Cited in Erika Krauße, *Ernst Haeckel.* Leipzig 1984, p. 25.
2  Ernst Haeckel to his parents, 30.8.1854, Ernst Haeckel Archiv, Jena.
3  Ernst Haeckel, *Die Radiolarien*, Berlin 1862, p. 17.
4  Ernst Haeckel, *Die Radiolarien*, Berlin 1862, p. 128.
5  Charles Darwin, *Über die Entstehung der Arten im Thier- und Pflanzenreich durch natürliche Züchtung oder die Erhaltung der vervollkomm-neten Rassen im Kampfe um's Daseyn.* Translated from the second English edition and annotated by H. G. Bronn, Stuttgart 1860.
6  Ernst Haeckel, *Die Radiolarien*, Berlin 1862, p. 232f. (note).
7  Ernst Haeckel in a letter to his parents, 1.11.1852, Ernst Haeckel Archiv, Jena.
8  Ernst Haeckel, *Über die Eier der Scomberesoces.* J. Müllers Archiv f. Anatomie und Physiologie 1855, pp. 23–32.
9  Ernst Haeckel in letters to his wife, 1859/60. Published with an introduction by H. Schmidt, Leipzig 1921, p. 69.
10  Ernst Haeckel, *Kunstformen der Natur.* Leipzig 1899–1904, printed in English as *Ernst Haeckel: Art Forms in Nature*: Munich, London, New York 1998.
11  Ernst Haeckel to Anna Sethe, 16.2.1860, quoted in: Georg Uschmann, *Ernst Haeckel. Biographie in Briefen, mit Erläuterungen*, Gütersloh 1984, p. 62f.
12  G. Fritsch, O. Müller, *Die Sculptur und die feineren Structurverhältnisse der Diatomaceen mit vorzugsweiser Berücksichtigung der als Probeobjecte benutzten Species.* Abt. 1. Berlin, London 1870.

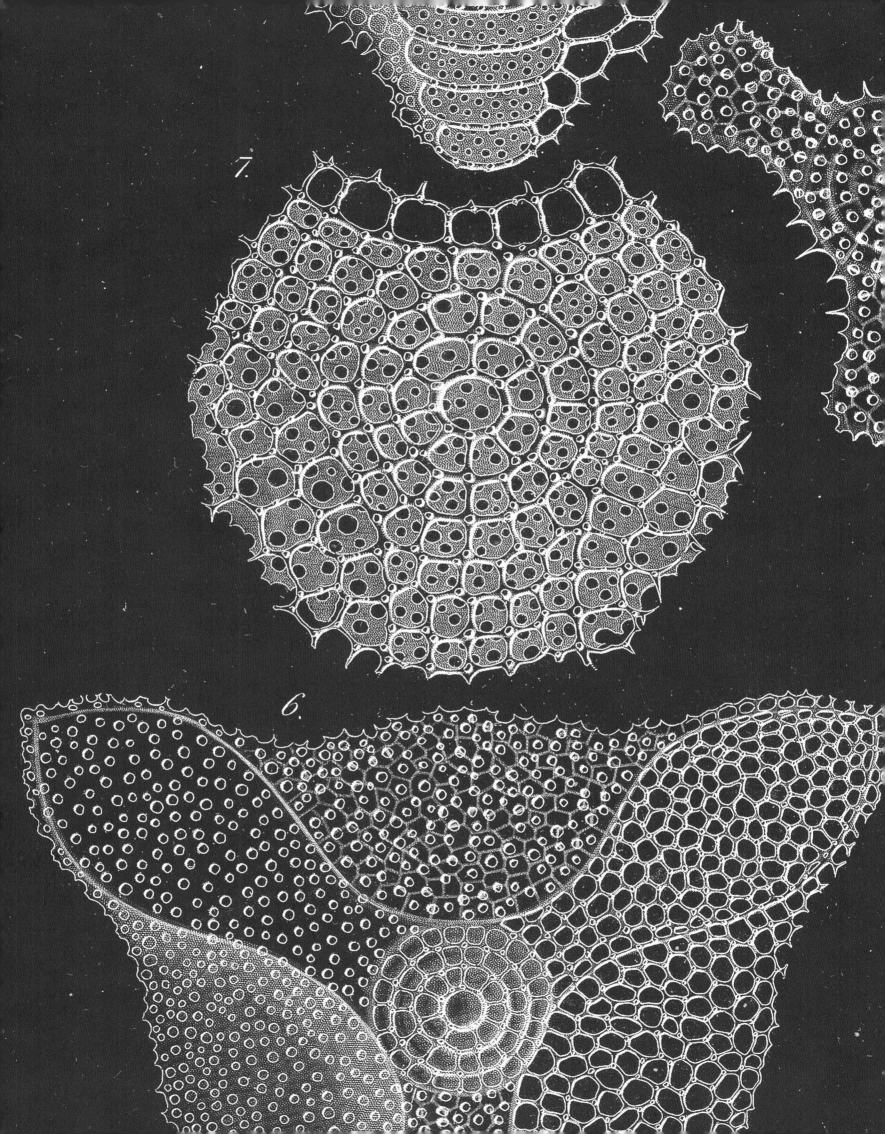

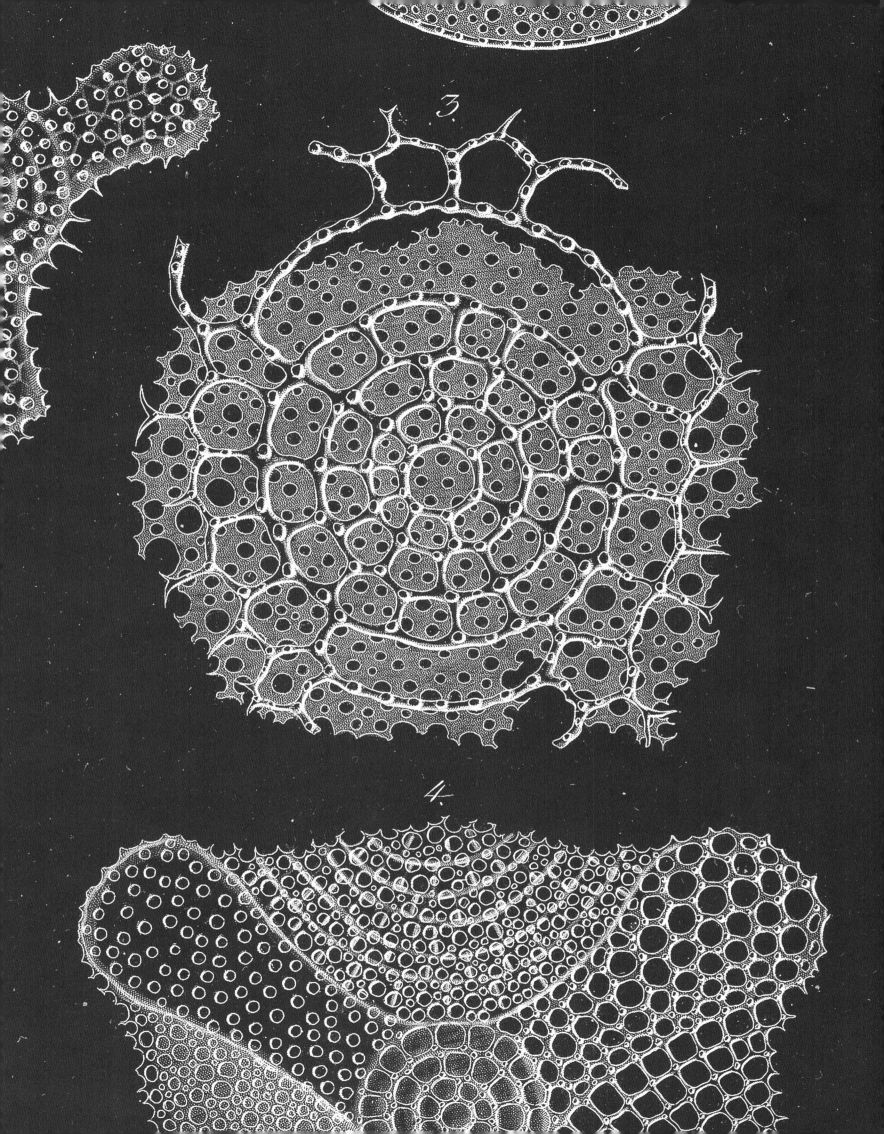

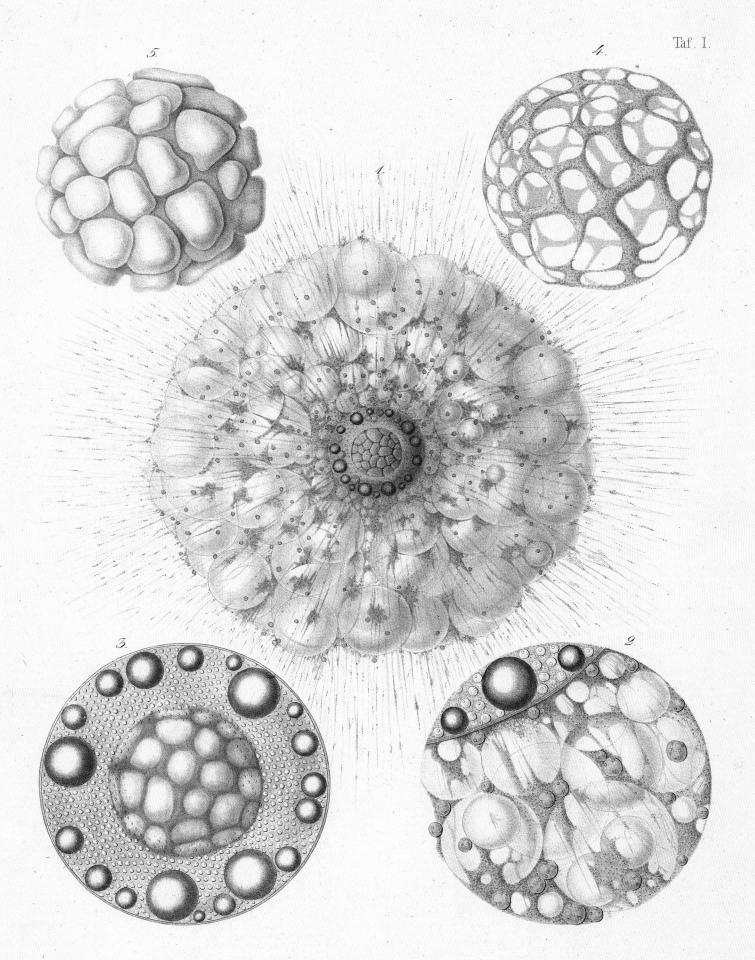

*5.*

*4.*

*1.*

*3.*

*2.*

1–5. Thalassicolla pelagica, Hkl.

E. Haeckel del.

Wagenschieber sc.

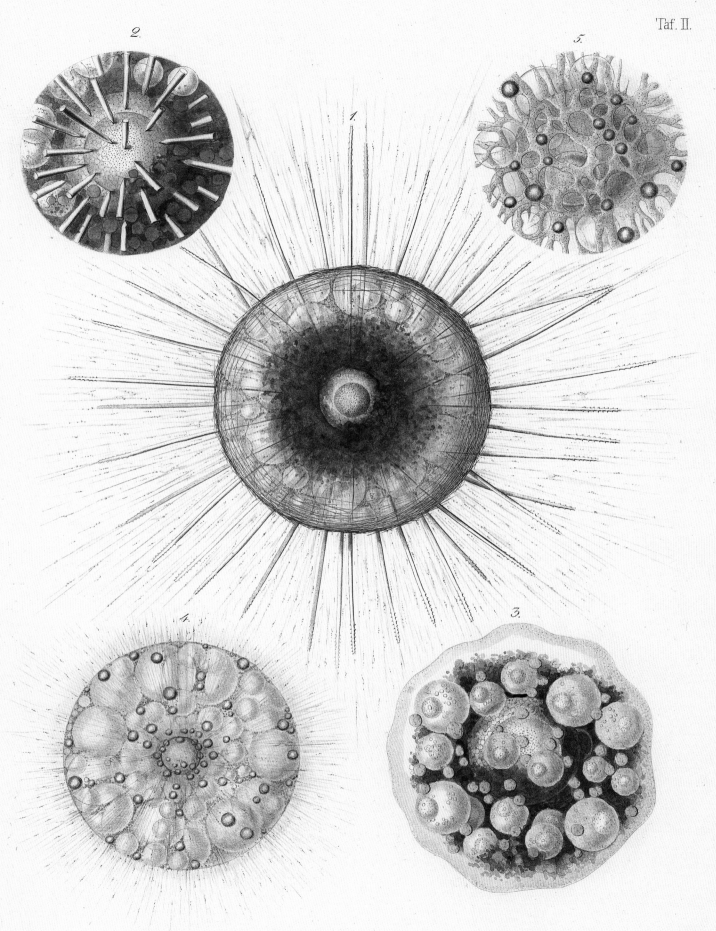

1. 2. Aulacantha scolymantha, Hkl. 3. Thalassicolla Zanclea, Hkl.

4. 5. Thalassolampe margarodes, Hkl.

E. Haeckel del.

Wagenschieber sc.

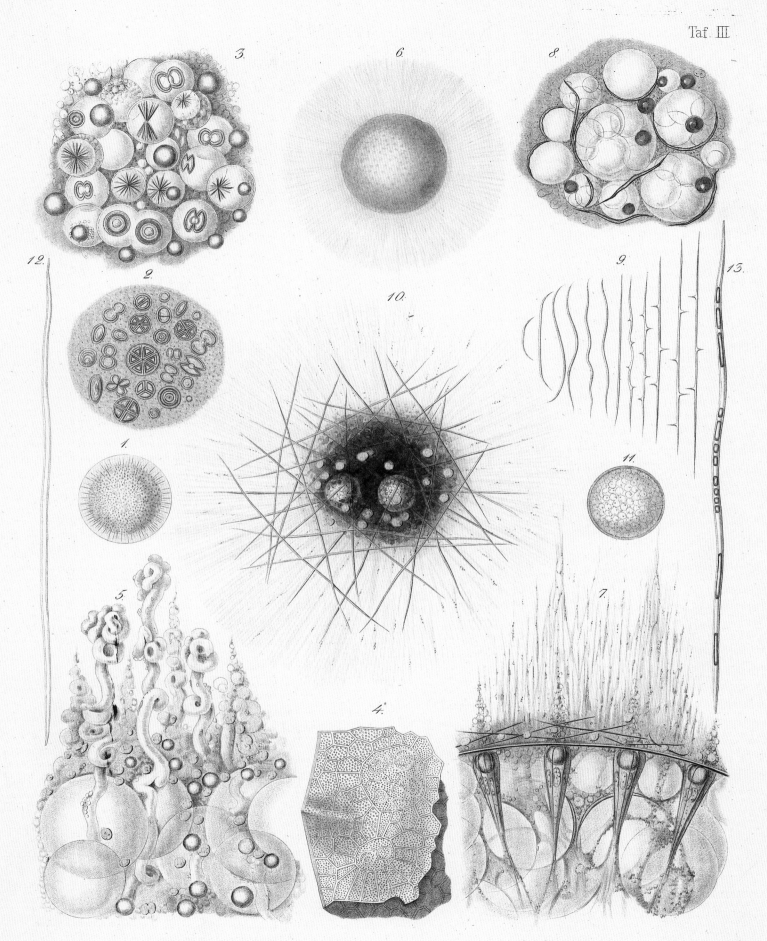

1–5. Thalassicolla nucleata, Huxley. 6–9. Physematium Mülleri, Schneider.
10–13. Thalassoplancta cavispicula, Hkl.

E. Haeckel del.

Wagenschieber sc.

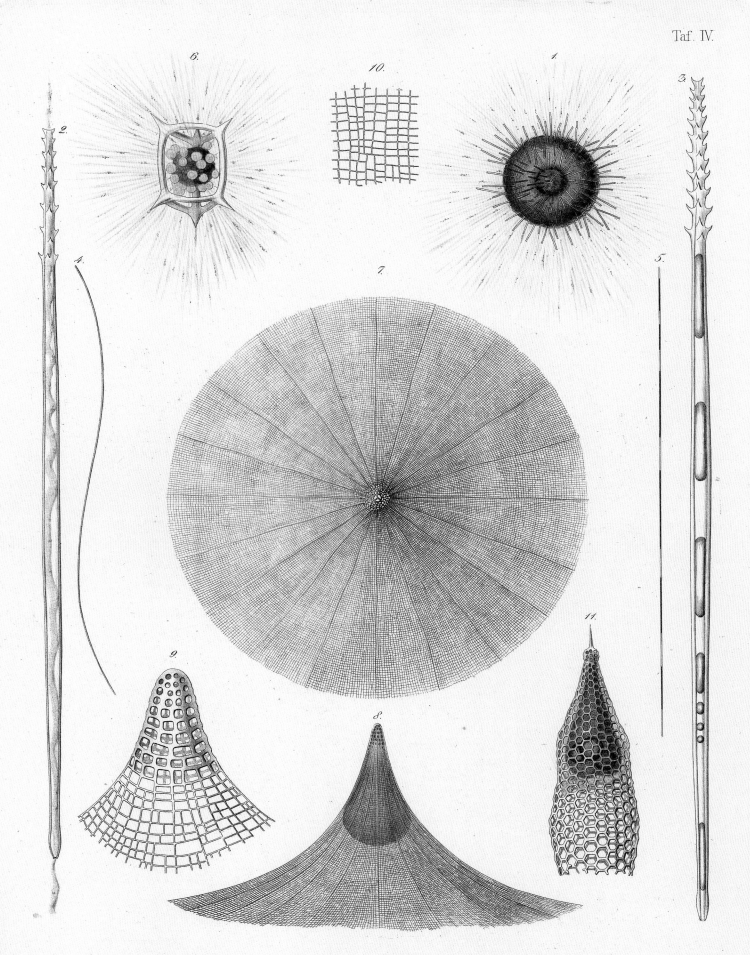

Taf. IV.

1–5. Aulacantha scolymantha, Hkl. 6. Acanthodesmia Prismatium, Hkl.
7–10. Litharachnium Tentorium, Hkl. 11. Eucyrtidium Lagena, Hkl.

E. Haeckel del.

Wagenschieber sc.

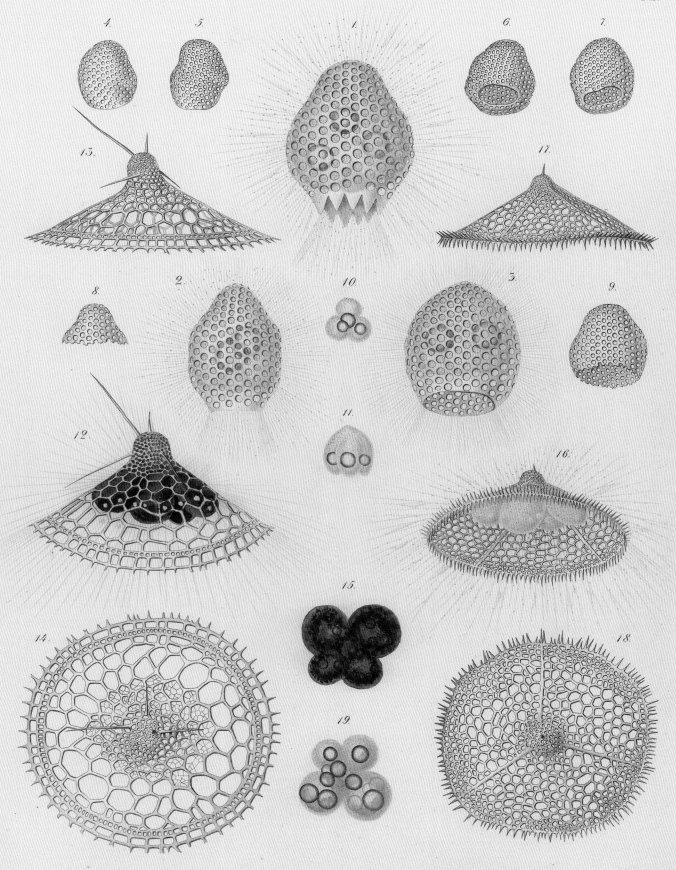

1. Carpocanium Diadema, Hkl. 2-11. Cyrtocalpis. 2. C. Amphora, Hkl. 3-11. C. obliqua, Hkl.
12-19. Eucecryphalus 12-15. E. Gegenbauri, Hkl. 16-19. E. Schultzei, Hkl.

E. Haeckel del.

Wagenschieber sc.

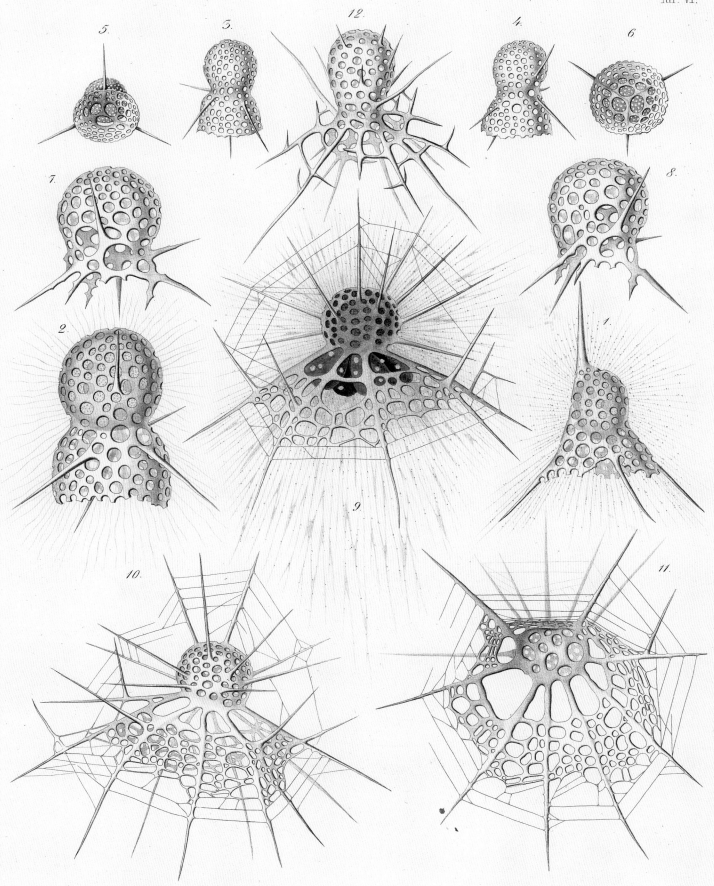

1. Dictyophimus Tripus, Hkl. 2–8. Lithomelissa Thoracites, Hkl.
9–12. Arachnocorys. 9–11. A. circumtexta, Hkl. 12. A. umbellifera, Hkl.

E. Haeckel del.

Wagenschieber sc.

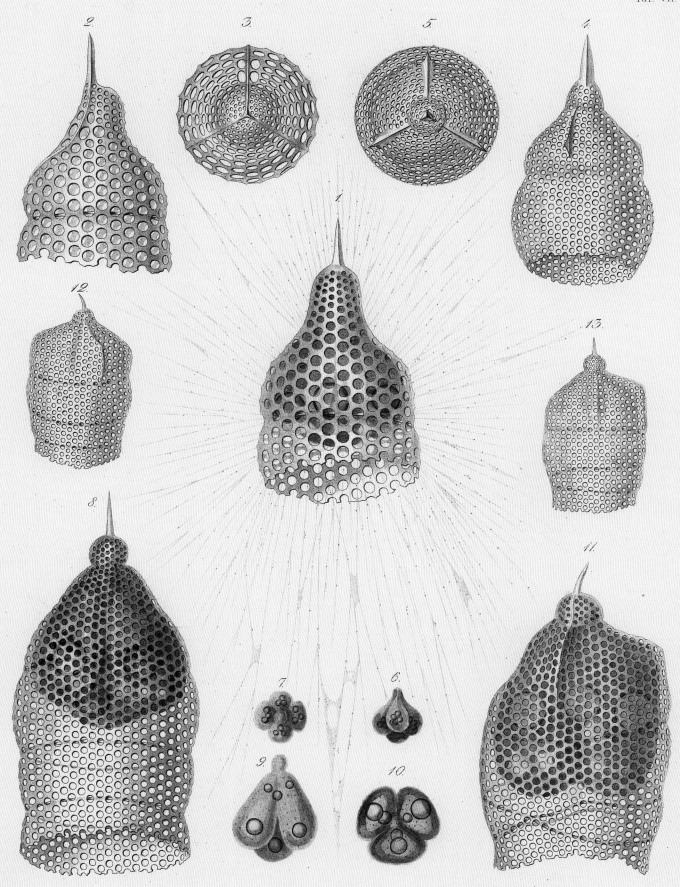

1–13. Eucyrtidium. 1–3. E. cranoides, Hkl. 4–7. E. carinatum, Hkl.
8–10. E. Galea, Hkl. 11–13. E. anomalum, Hkl.

E. Haeckel del.

Wagenschieber sc.

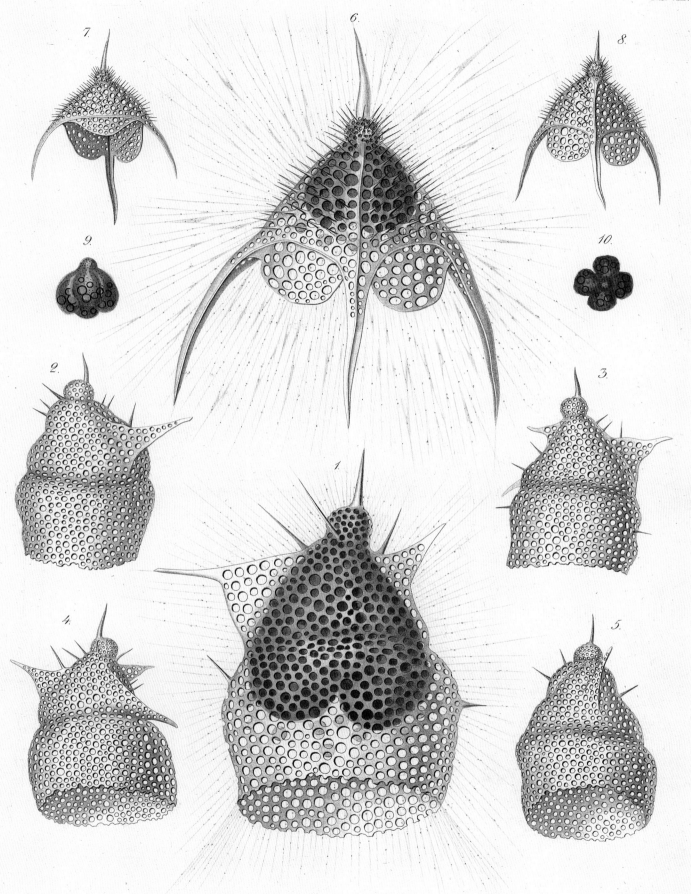

1–5. Dictyoceras Virchowii, Hkl. 6–10. Dictyopodium trilobum, Hkl.

E.Haeckel del.

Wagenschieber sc.

PLATE IX

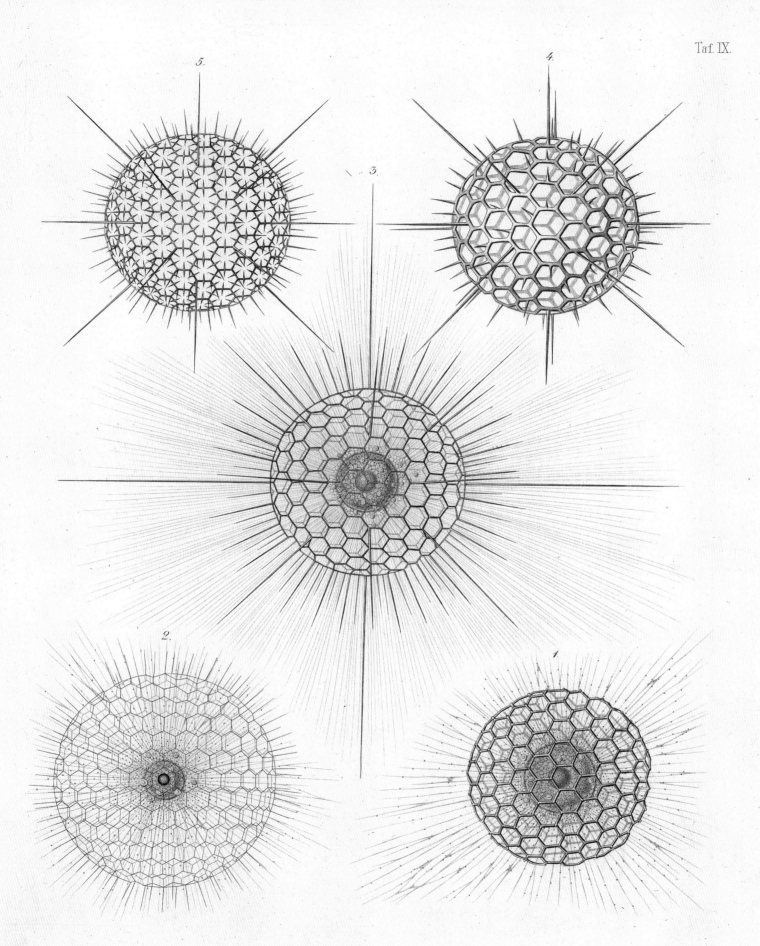

1–5. Heliosphaera. 1. H. inermis, Hkl. 2. H. tenuissima, Hkl. 3. H. actinota, Hkl.
4. H. echinoides, Hkl. 5. H. elegans, Hkl.

E. Haeckel del.

Wagenschieber sc.

PLATE X

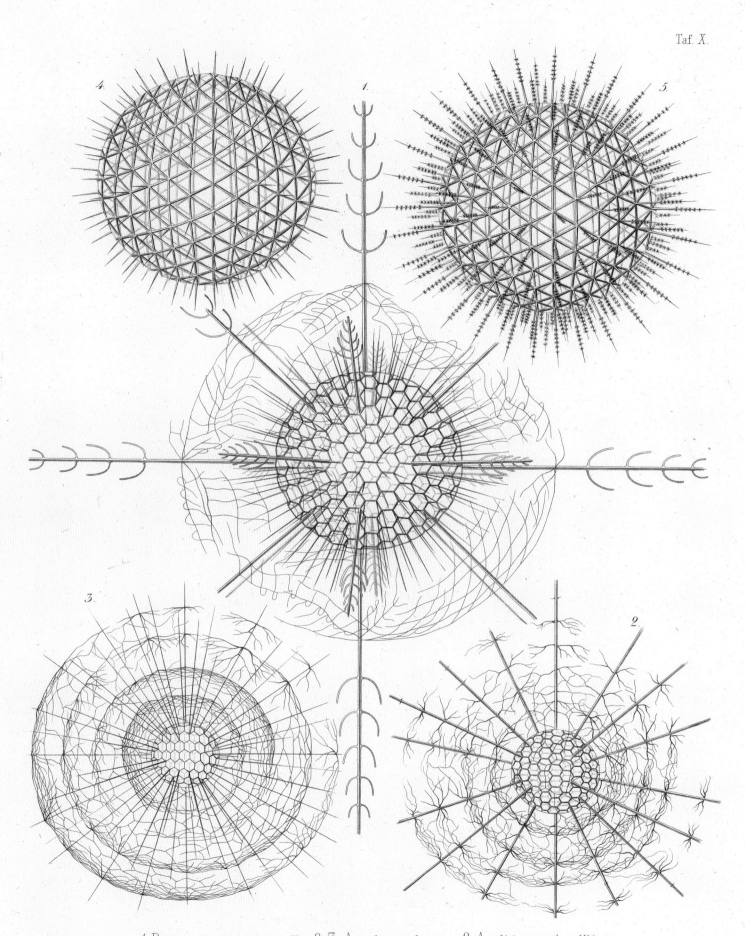

1.Diplosphaera ciliata, Hkl. 2.3. Arachnosphaera. 2. A. oligacantha, Hkl.

3. A. myriacantha, Hkl. 4. 5. Aulosphaera. 4. A. trigonopa, Hkl. 5. A. elegantissima, Hkl.

E. Haeckel del.

Wagenschieber sc.

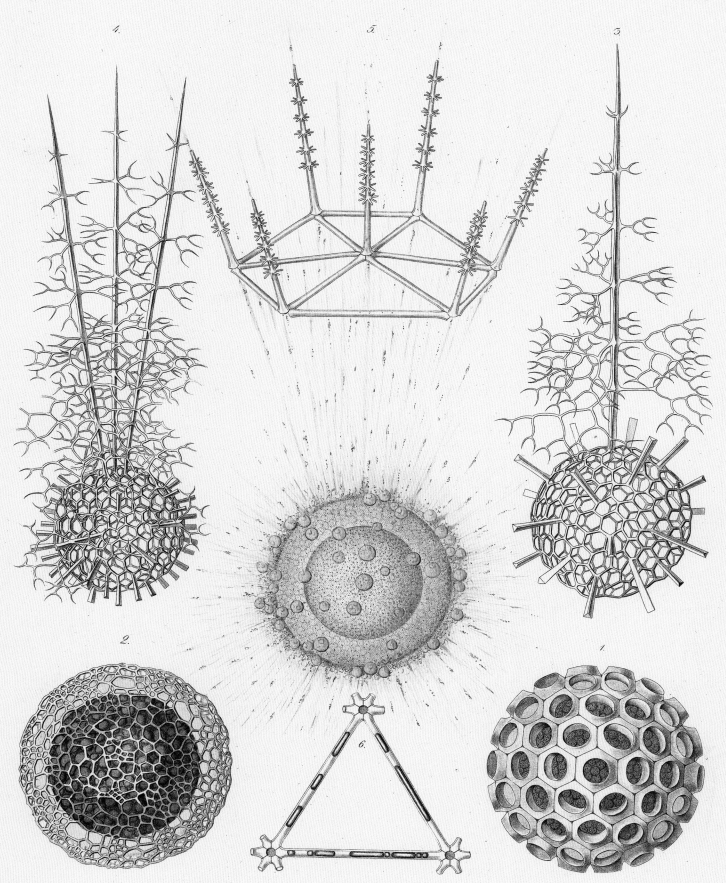

1. Ethmosphaera siphonophora, Hkl. 2. Cyrtidosphaera reticulata, Hkl. 3. 4. Arachnosphaera.
3. A. oligacantha, Hkl. 4. A. myriacantha, Hkl. 5. 6. Aulosphaera elegantissima, Hkl.

E. Haeckel del.

Wagenschieber sc.

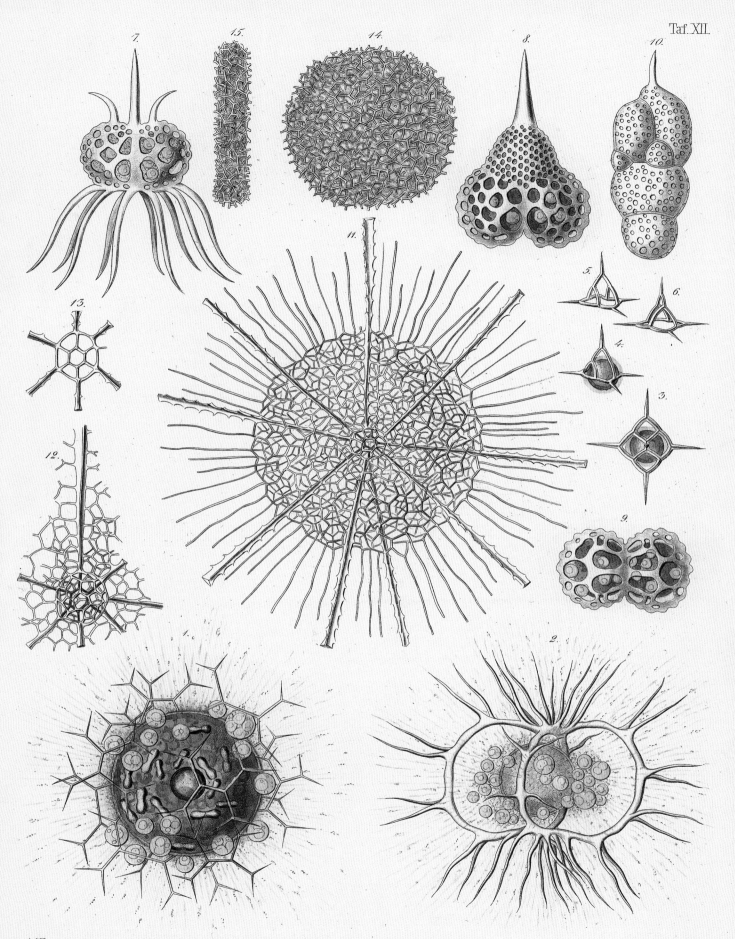

Taf. XII.

1. Thalassosphaera bifurca, Hkl. 2. Zygostephanus Mülleri, Hkl. 3-6. Dictyocha Messanensis, Hkl. 7. Petalospyris arachnoides, Hkl.
8.9. Spyridobotrys Trinacria, Hkl. 10. Botryocampe hexathalamia, Hkl. 11-13. Spongosphaera helioides, Hkl. 14.15. Spongodiscus Mediterraneus, Hkl.

E. Haeckel del.                                                                                    Wagenschieber sc.

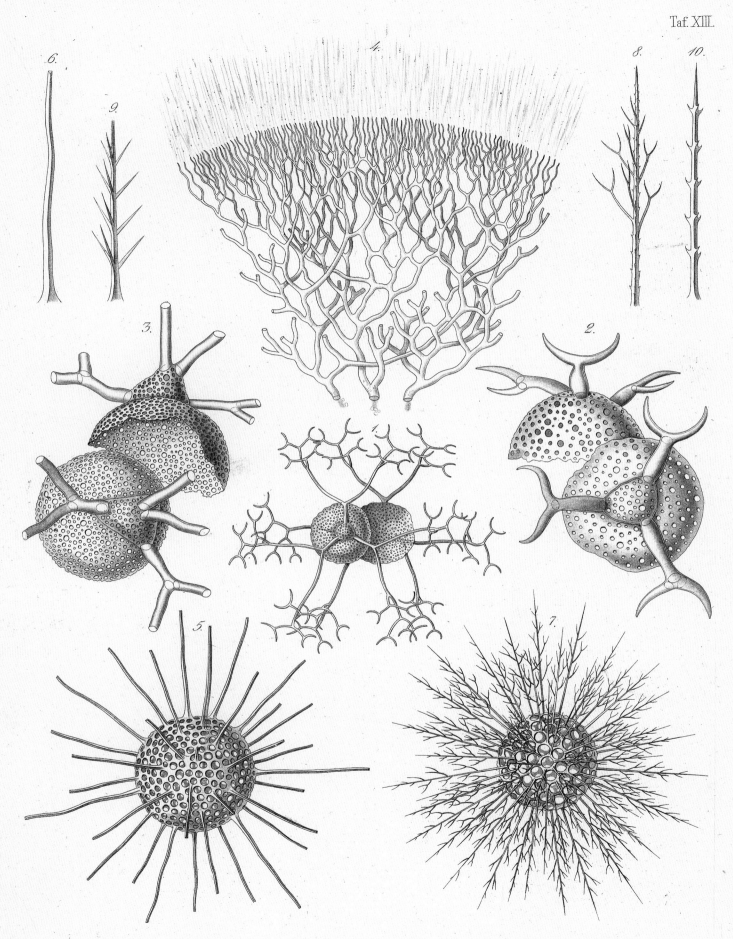

1-4. Coelodendrum ramosissimum, Hkl. 5. 6. Rhaphidococcus simplex, Hkl. 7-10. Cladococcus.
7. 8. C. bifurcus, Hkl. 9. C. spinifer, Hkl. 10. C. dentatus, Hkl.

E.Haeckel del.

Wagenschieber sc.

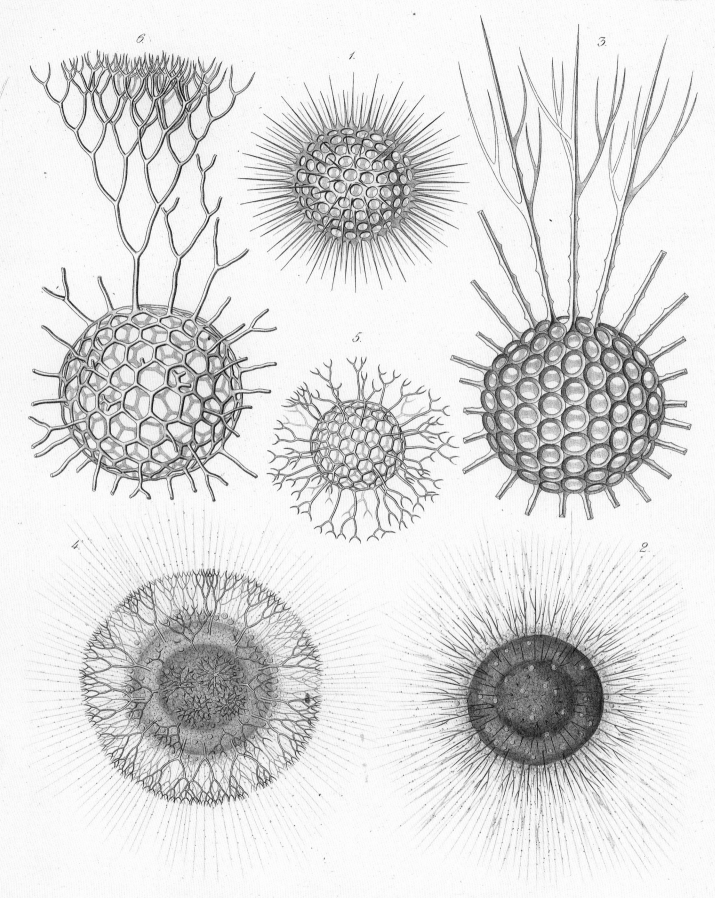

E. Haeckel del.

Wagenschieber sc.

1. Rhaphidococcus acufer, Hkl. 2–6. Cladococcus.
2. 3. C. viminalis, Hkl. 4–6. C. cervicornis, Hkl.

PLATE XV

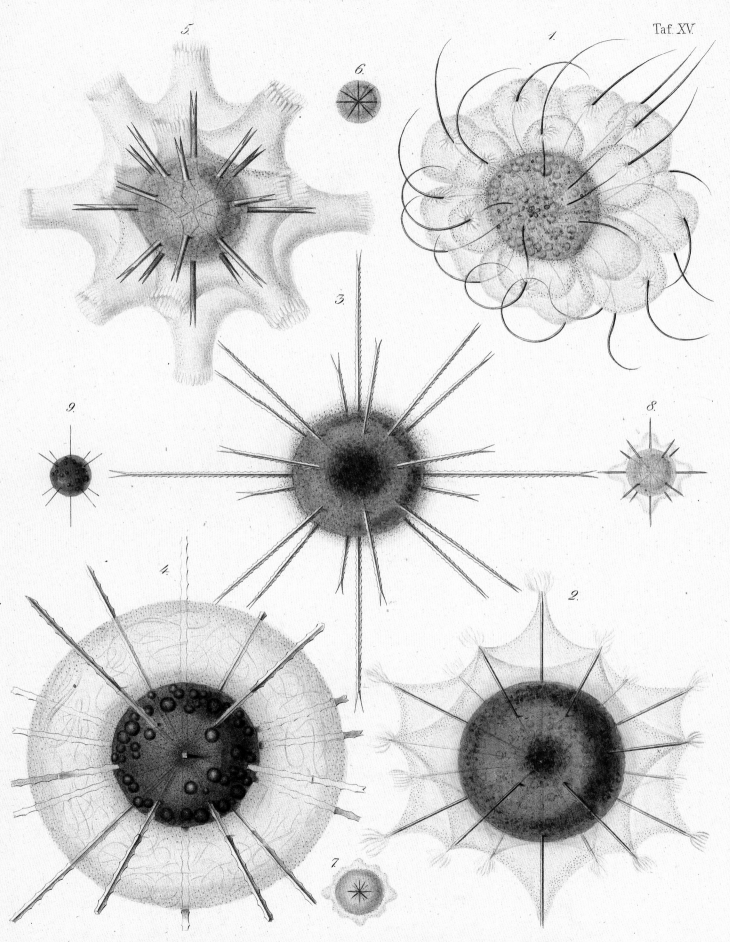

Taf. XV.

1–9. Acanthometra. 1. A. elastica, Hkl. 2. A. bulbosa, Hkl. 3. A. Mülleri, Hkl.
4. A. fragilis, Hkl. 5. A. brevispina, Hkl. 6–9. Acanthometrae juvenes.

E. Haeckel del.

Wagenschieber sc.

PLATE XVI

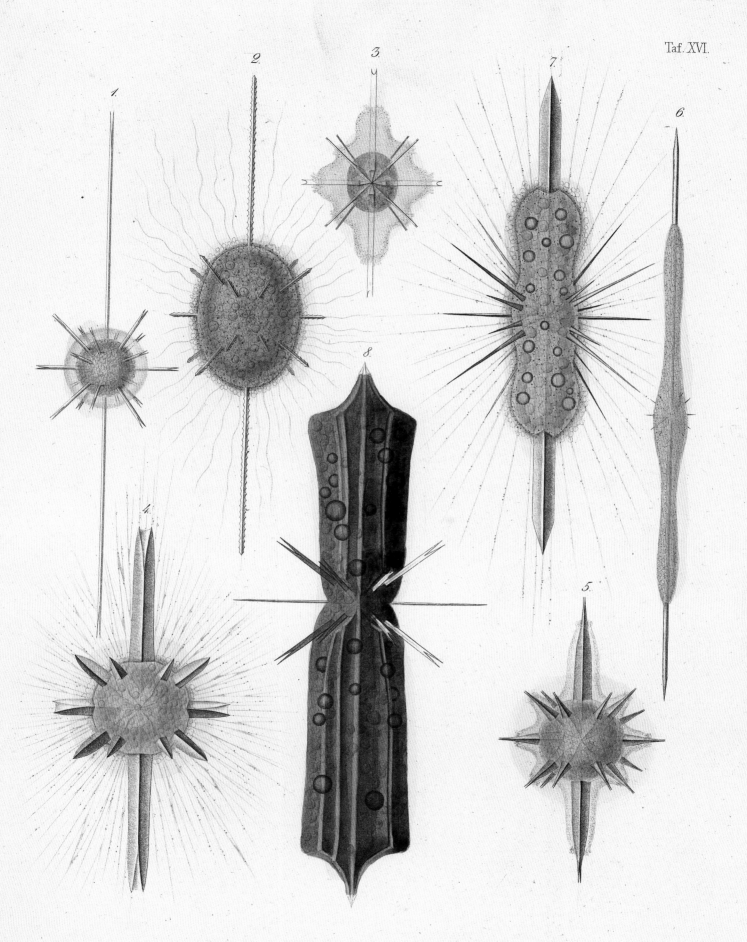

Taf. XVI.

1—8. Amphilonche. 1. A. tenuis, Hkl. 2. A. denticulata, Hkl. 3. A. complanata, Hkl. 4. A. Messanensis, Hkl.
5. A. tetraptera, Hkl. 6. A. belonoides, Hkl. 7. A. heteracantha, Hkl. 8. A. anomala, Hkl.

E. Haeckel del.

Wagenschieber sc.

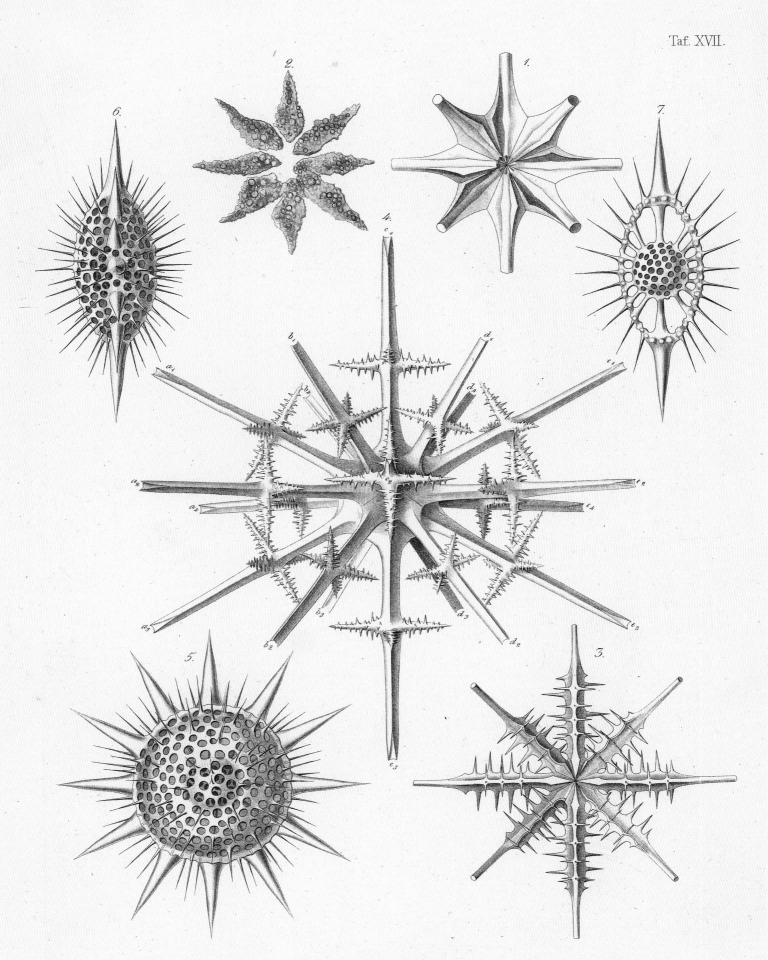

E. Haeckel del.

1. 2. Acanthometra Sicula, Hkl. 3. 4. Xiphacantha. 3. X. serrata, Hkl.
4. X. spinulosa, Hkl. 5–7. Heliodiscus Phacodiscus, Hkl.

Wagenschieber sc.

PLATE XVIII

Fig. 1  *Acanthometra elastica*

Fig. 2  *Acanthometra bulbosa*

Figs. 3a, 3b  *Acanthometra dolichoscia*

Figs. 4a, 4b  *Acanthometra compressa*

Fig. 5  *Acanthometra tetracopa*

Fig. 6  *Acanthometra Muelleri*

Fig. 7  *Acanthometra fragilis*

Fig. 8  *Acanthometra sicula*

Fig. 9  *Acanthometra brevispina*

Fig. 10  *Acanthometra quadrifolia*

Fig. 11  *Acanthometra cuspidata*

Fig. 12  *Acanthometra claparèdei*

Fig. 13  *Xiphacantha cruciata*

Figs. 14a, 14b  *Xiphacantha serrata*

Figs. 15a, 15b  *Xiphacantha quadridentata*

Fig. 16  *Amphilonche tenuis*

Fig. 17  *Amphilonche denticulata*

Figs. 18a, 18b  *Amphilonche complanata*

Fig. 19  *Amphilonche messanensis*

Fig. 20  *Amphilonche tetraptera*

Fig. 21  *Amphilonche belonoides*

Figs. 22a, 22b  *Amphilonche elongata*

Figs. 23a, 23b  *Amphilonche anomala*

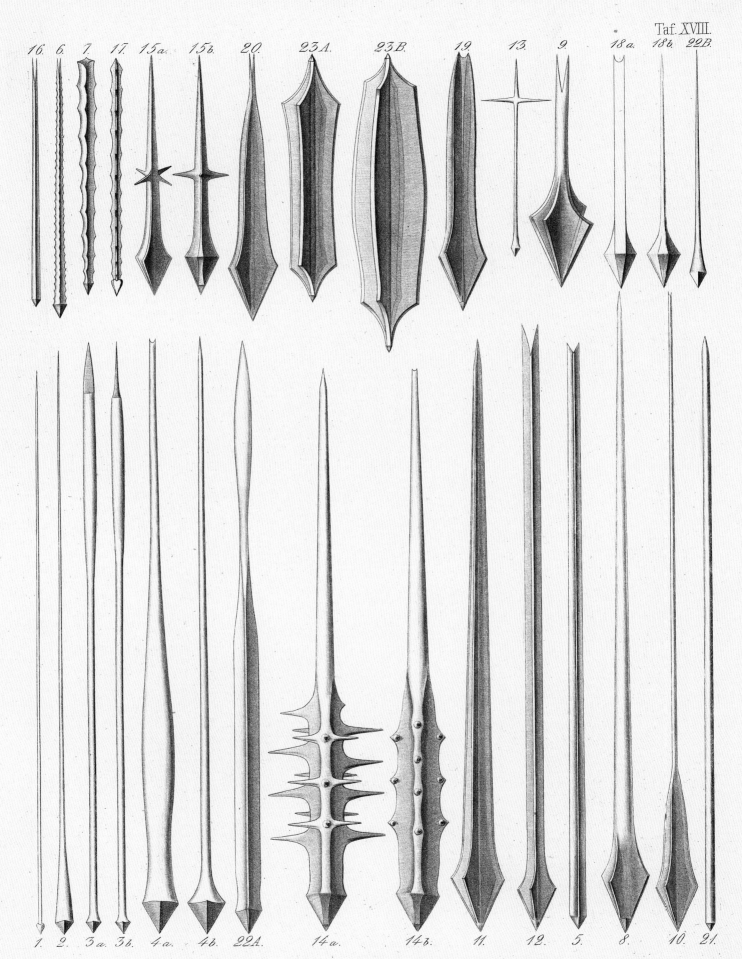

*16. 6. 7. 17. 15a. 15b. 20. 23A. 23B. 19. 13. 9. 18a. 18b. 22B.*

*1. 2. 3a. 3b. 4a. 4b. 22A. 14a. 14b. 11. 12. 5. 8. 10. 21.*

1–23. Aculei Acanthostauridum, 1–12. Generis Acanthometrae,
13–15. Generis Xiphacanthae, 16–23. Generis Amphilonchae.

E. Haeckel del.

Wagenschieber sc.

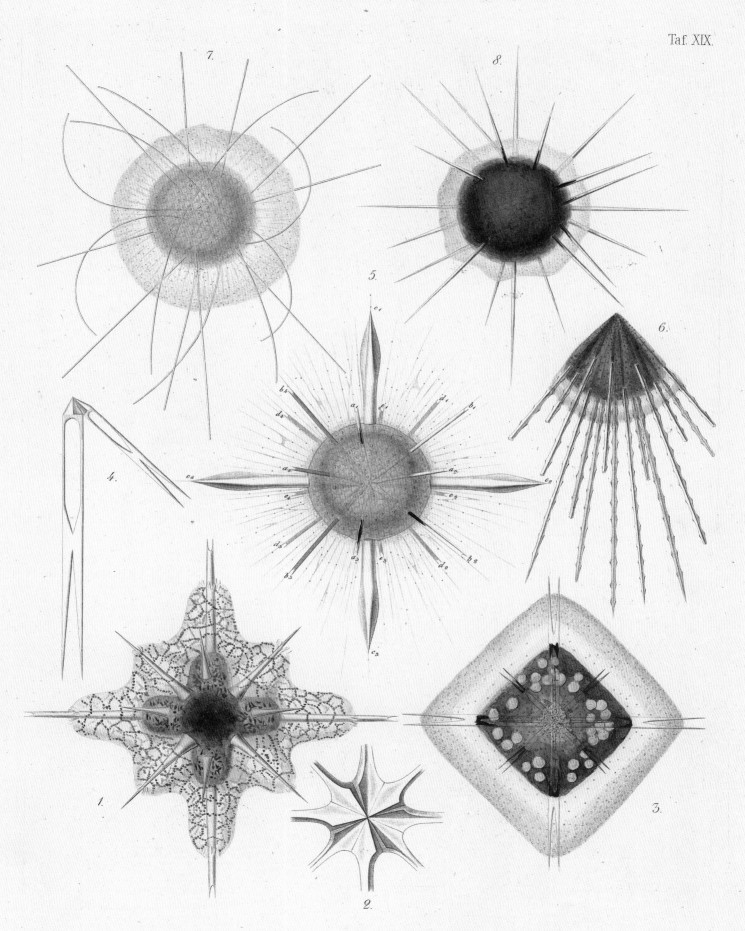

1–5. Acanthostaurus. 1. 2. A. purpurascens, Hkl. 3. 4. A. Forceps, Hkl. 5. A. hastatus, Hkl.
6. Litholophus Rhipidium, Hkl. 7. 8. Acanthochiasma. 7. A. Krohnii, Hkl. 8. A. fusiforme, Hkl.

E. Haeckel del.

Wagenschieber sc.

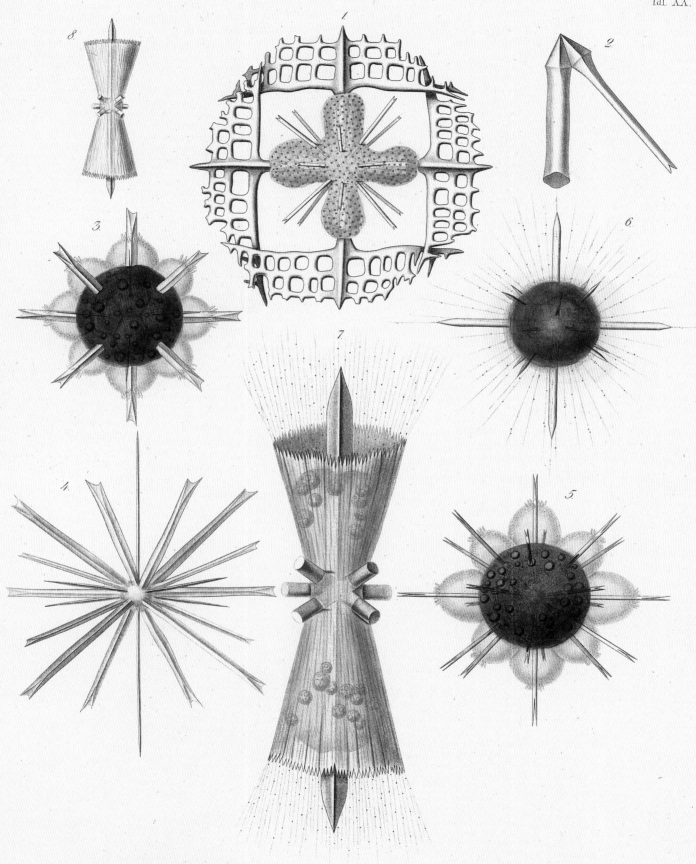

1.2. Lithoptera Mülleri, Hkl. 3—6. Astrolithium. 3. 4. A. dicopum, Hkl.
5. A. bifidum, Hkl. 6. A. cruciatum, Hkl 7. 8. Diploconus Fasces, Hkl.

E. Haeckel del.

Wagenschieber sc.

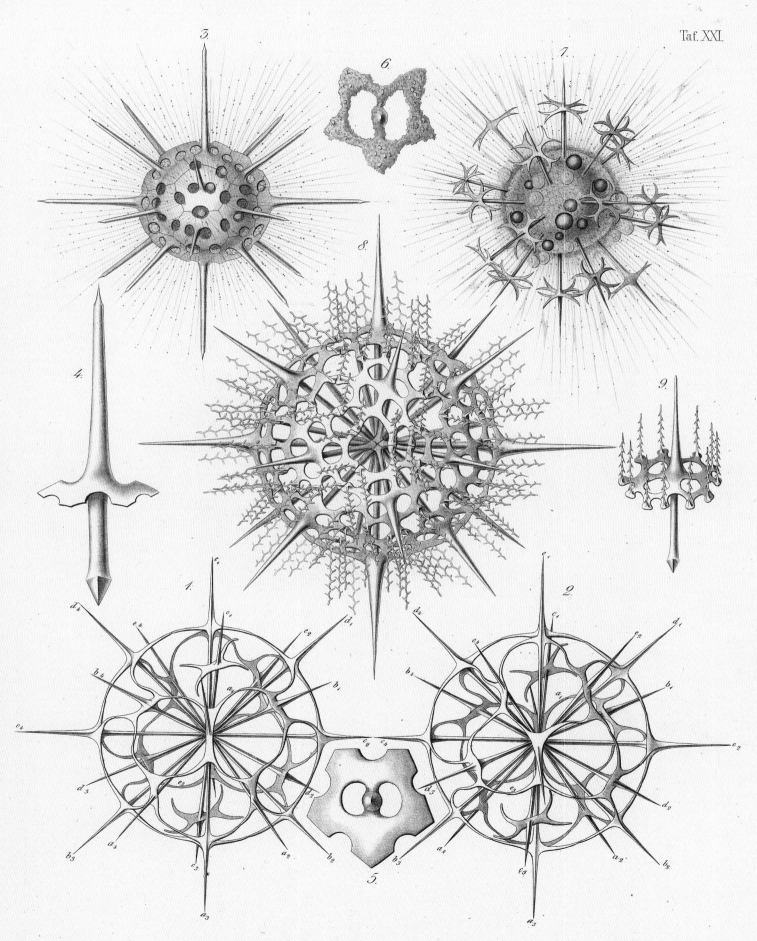

1–9. Dorataspis. 1. 2. D. bipennis, Hkl. 3–6. D. loricata, Hkl.

7–9. D. polyancistra, Hkl.

E.Haeckel del.

Wagenschieber sc.

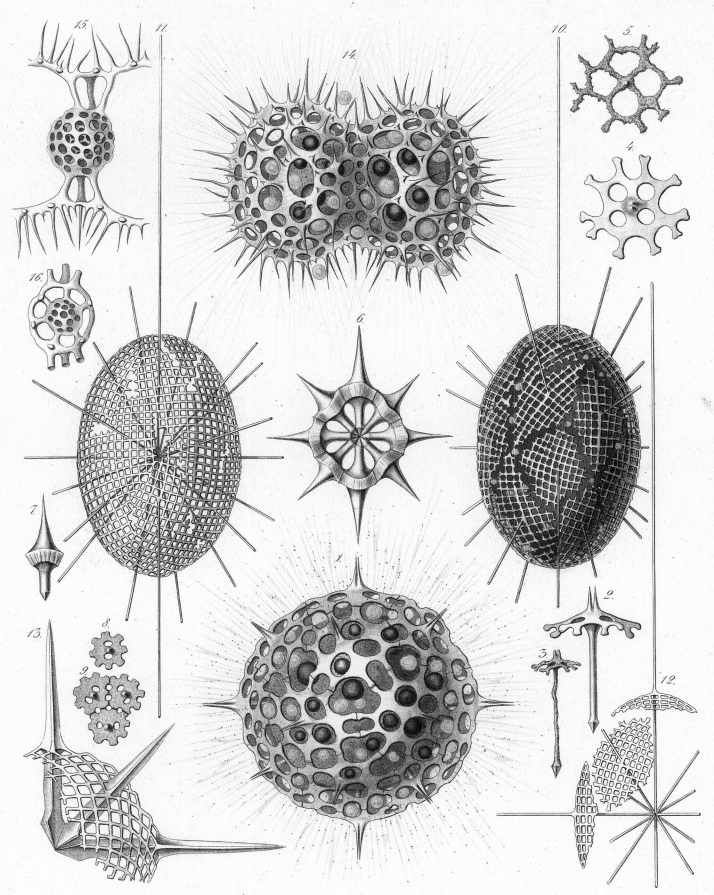

1–9. Dorataspis. 1–5. D. Diodon, Hkl. 6–9. D. solidissima, Hkl. 10–13. Haliommatidium.
10–12. H. Mülleri, Hkl. 13. H. tetragonopum, Hkl. 14–16. Didymocyrtis Ceratospyris.

E. Haeckel del.

Wagenschieber sc.

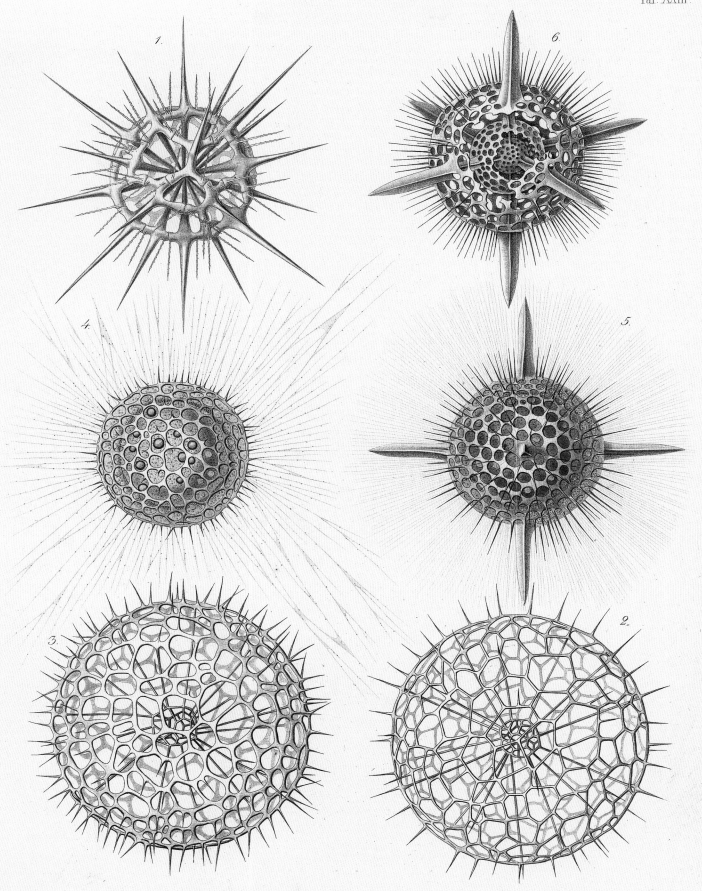

1. Dorataspis costata, Hkl. 2-4. Haliomma. 2. H. capillaceum, Hkl.
3. 4. H. Erinaceus, Hkl. 5. 6. Actinomma Asteracanthion, Hkl.

E. Haeckel del.

Wagenschieber sc.

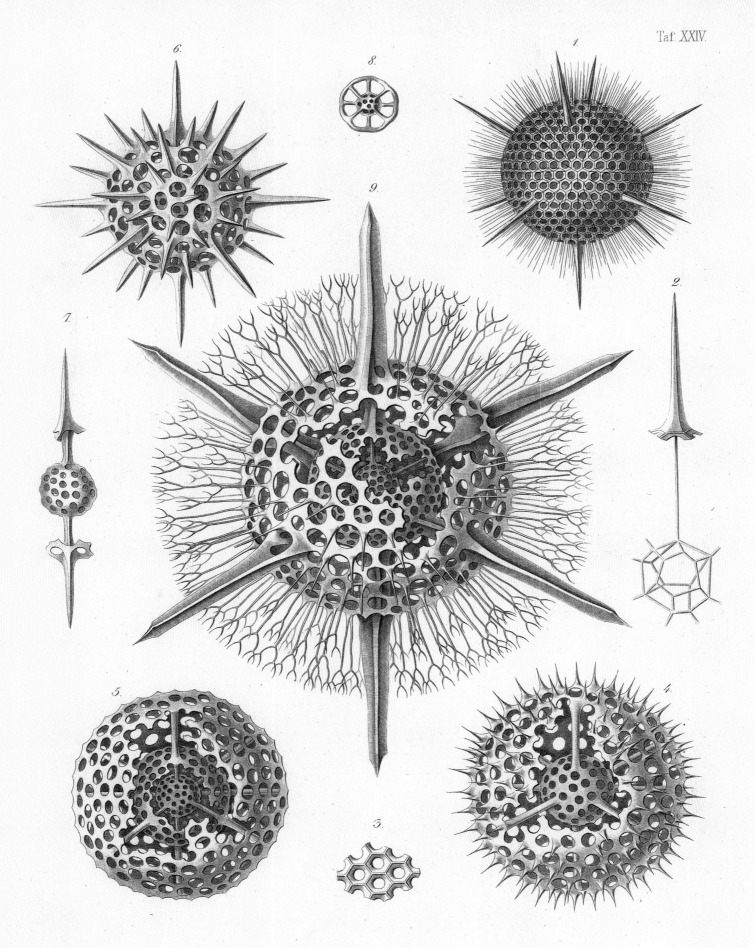

1–4. Haliomma. 1–3. H. Echinaster, Hkl. 4. H. Castanea, Hkl. 5–9. Actinomma.
5. A. inerme, Hkl. 6–8. A. Trinacrium, Hkl. 9. A. drymodes, Hkl.

E. Haeckel del.

Wagenschieber sc.

1–10. Rhizosphaera. 1–7. R. trigonacantha, Hkl. 8–10. R. leptomita, Hkl.

E. Haeckel del.

Wagenschieber sc.

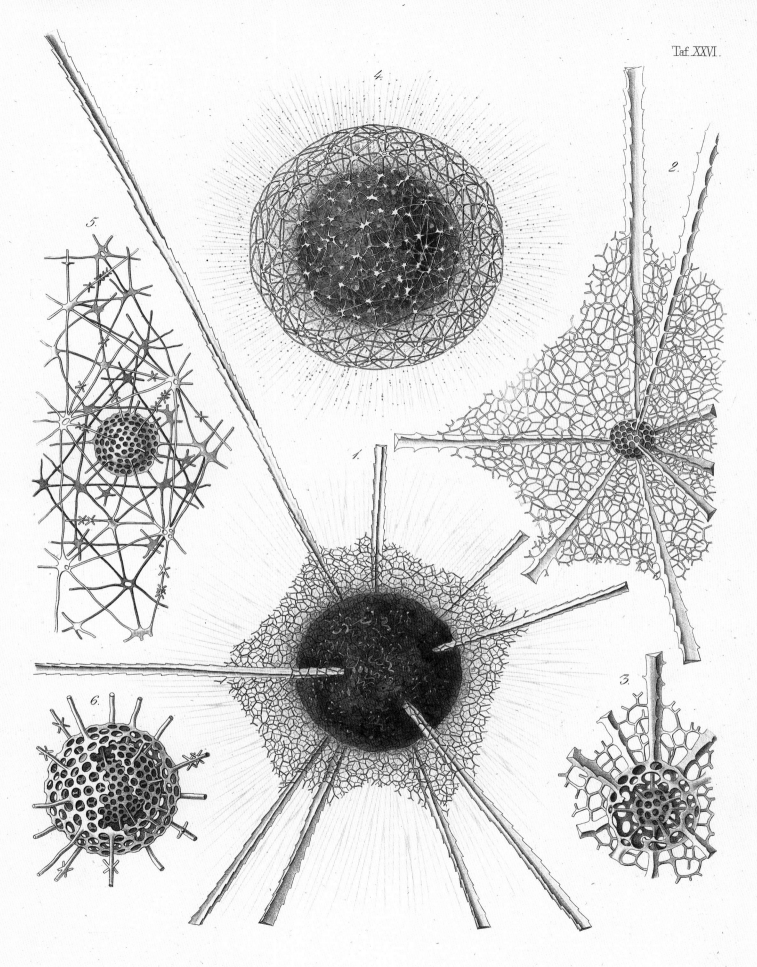

1-3. Spongosphaera streptacantha, Hkl. 4-6. Dictyosoma trigonizon, Hkl.

E.Haeckel del.

Wagenschieber sc.

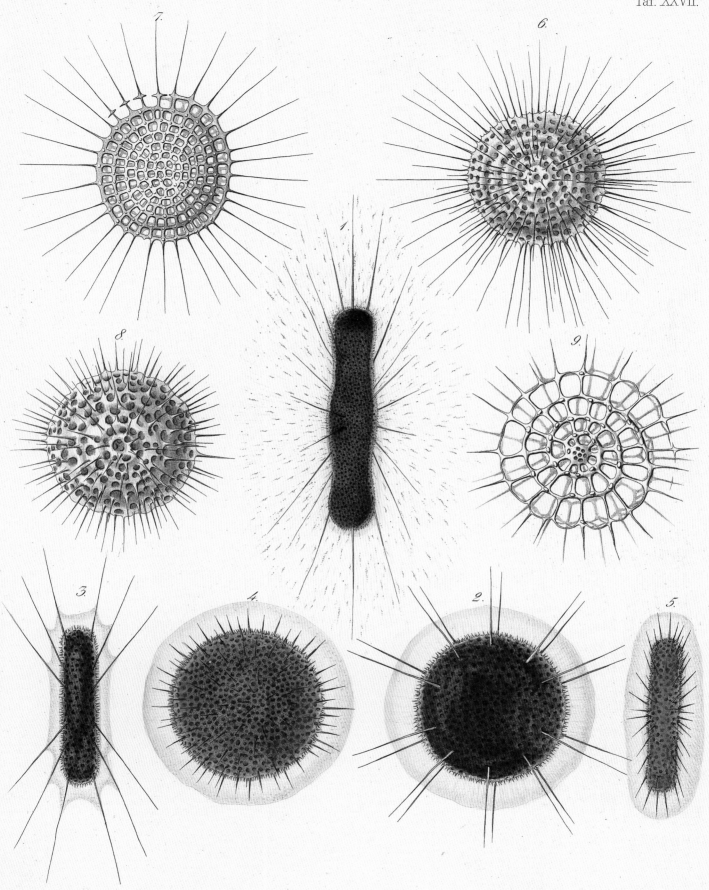

1. Spongurus cylindricus, Hkl. 2–5. Spongotrochus. 2. 3. S. longispinus, Hkl. 4. 5. S. brevispinus, Hkl.
6–9. Lithelius. 6. 7. L. spiralis, Hkl. 8. 9. L. Alveolina, Hkl.

E. Haeckel del.

Wagenschieber sc.

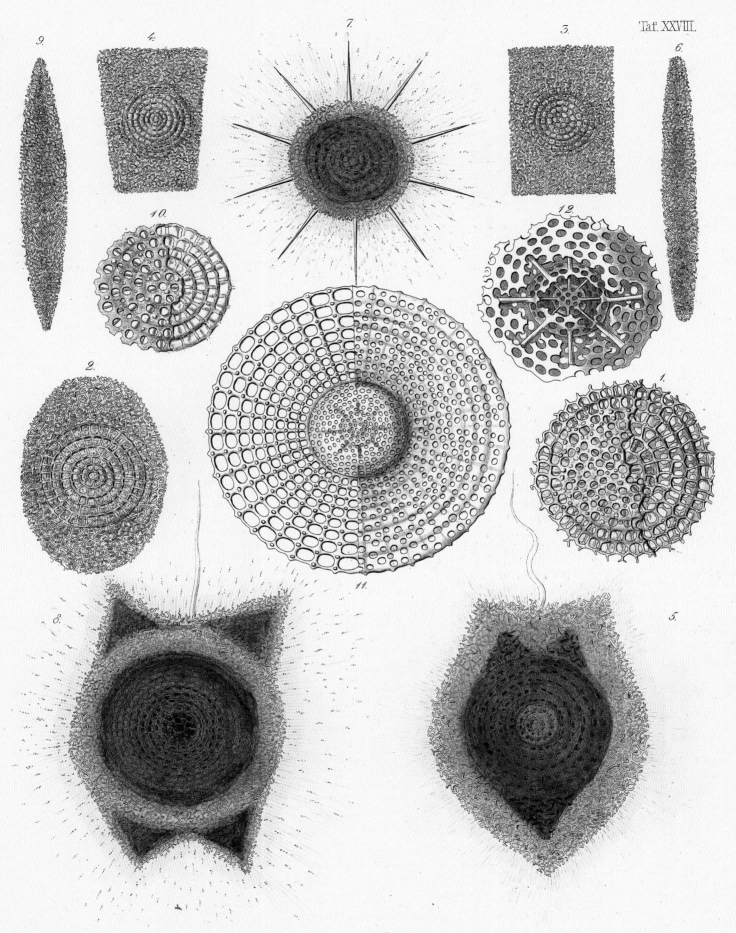

1–6. Spongocyclia 1. S. cycloides, Hkl. 2. S. elliptica, Hkl. 3. S. orthogona, Hkl. 4. S. Scyllaea, Hkl. 5. 6. S. Charybdaea, Hkl.
7. Stylospongia Huxleyi, Hkl. 8–10. Spongasteriscus quadricornis, Hkl. 11. 12. Coccodiscus Darwinii, Hkl.

E. Haeckel del.

Wagenschieber sc.

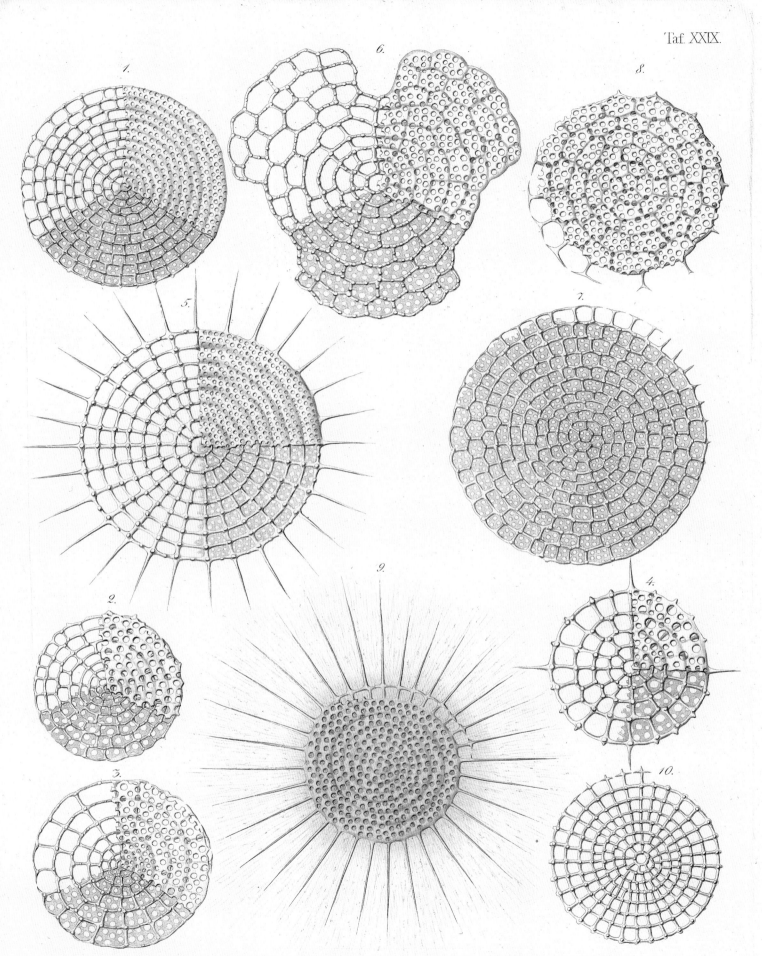

1-3. Trematodiscus. 1. T. orbiculatus, Hkl. 2. T. Sorites, Hkl. 3. T. heterocyclus, Hkl. 4. 5. Stylodictya. 4. S. quadrispina, Hkl.

5. S. multispina, Hkl. 6. Rhopalastrum truncatum, Hkl. 7. 8. Discospira. 7. D. helicoides, Hkl. 8. D. Operculina, Hkl. 9. Stylospira Edwardsii, Hkl.

E. Haeckel del.

Wagenschieber sc

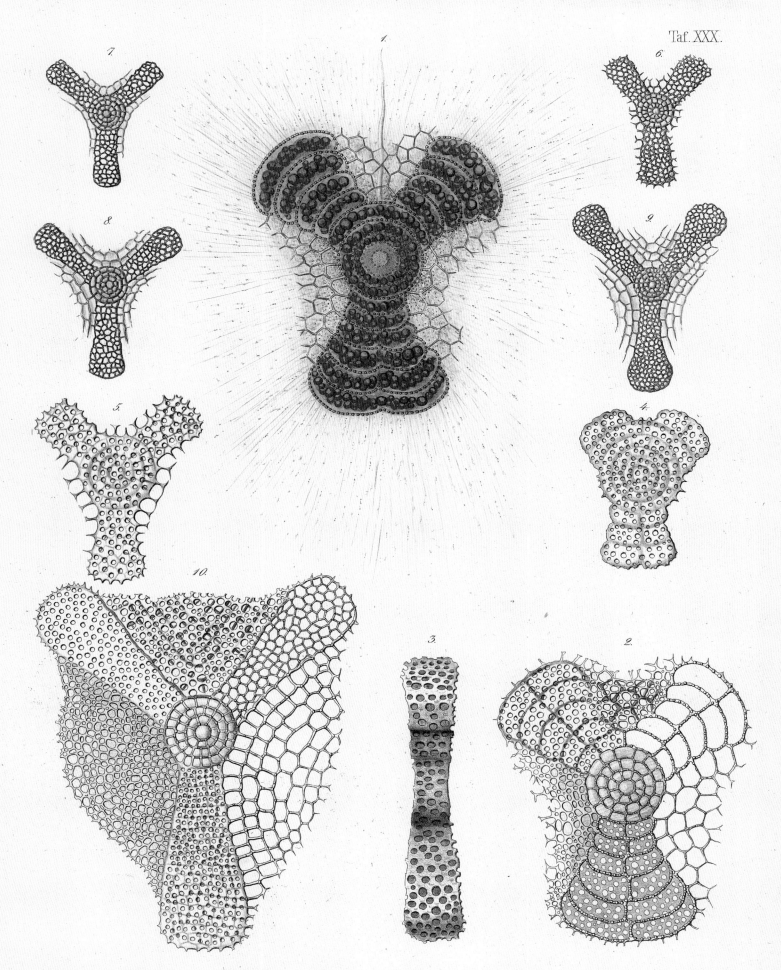

*7.*

*1.*

*6.*

*8.*

*9.*

*5.*

*4.*

*10.*

*3.*

*2.*

1—10. Euchitonia. 1-4. E. Virchowii, Hkl. 5-10. E. Mülleri, Hkl.

E. Haeckel del.

Wagenschieber sc.

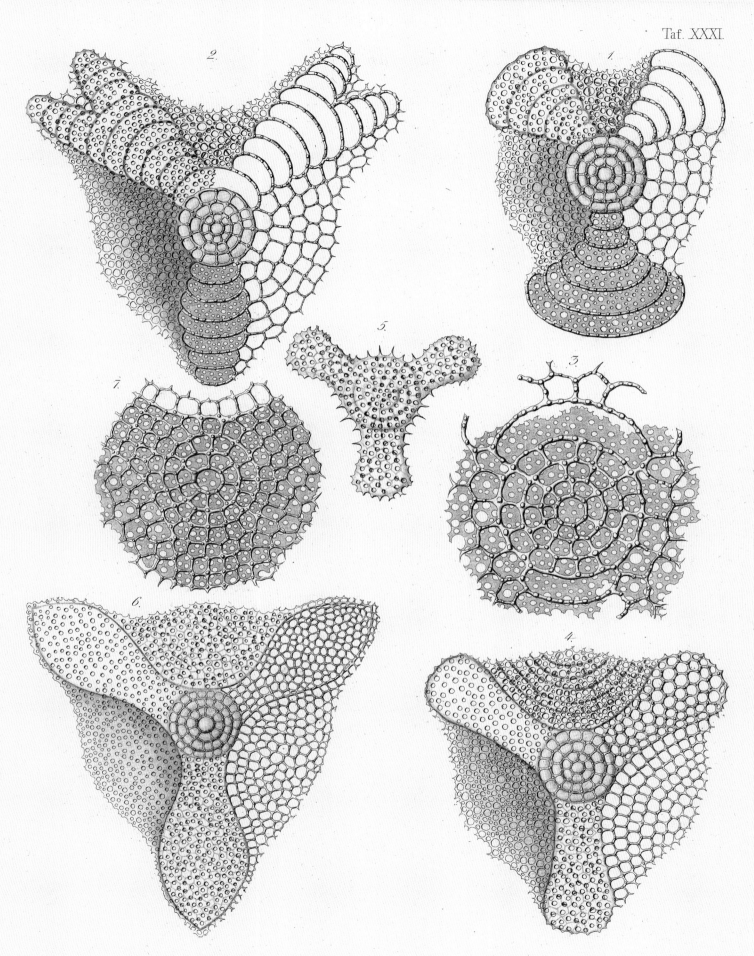

1—7. Euchitonia. 1. E. Beckmanni, Hkl. 2. 3. E. Gegenbauri, Hkl.
4. 5. E. Leydigii, Hkl. 6. 7. E. Köllikeri, Hkl.

E. Haeckel del.

Wagenschieber sc.

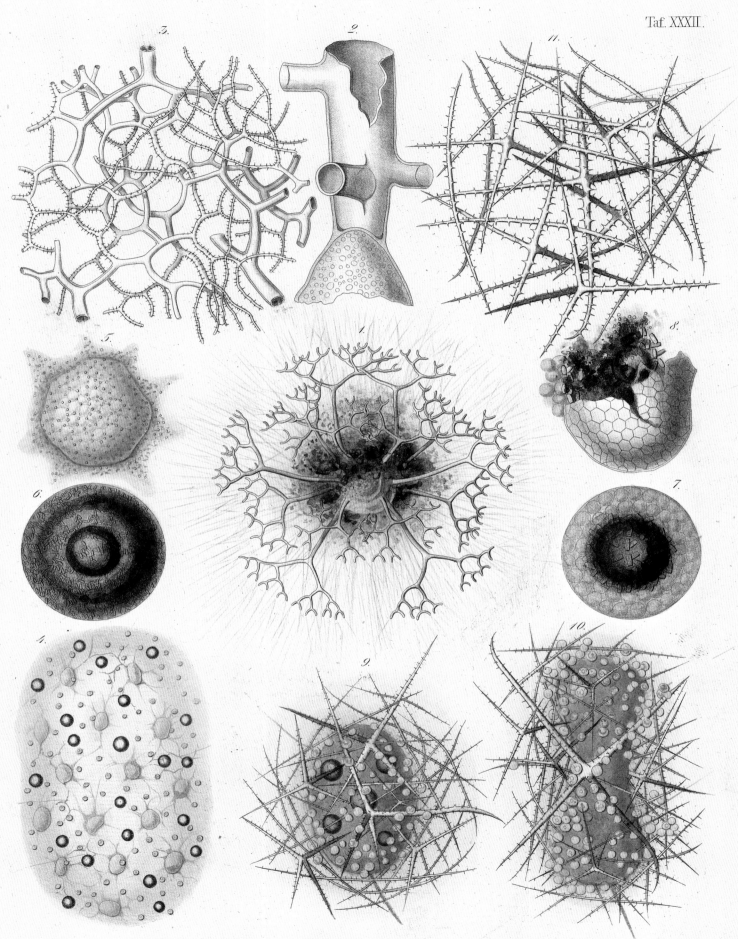

1–3. Coelodendrum gracillimum, Hkl. 4–8. Collozoum. 4 5. C. pelagicum, Hkl.

6–8. C. coeruleum, Hkl. 9–11. Rhaphidozoum acuferum, Hkl.

E. Haeckel del.

Wagenschieber sc

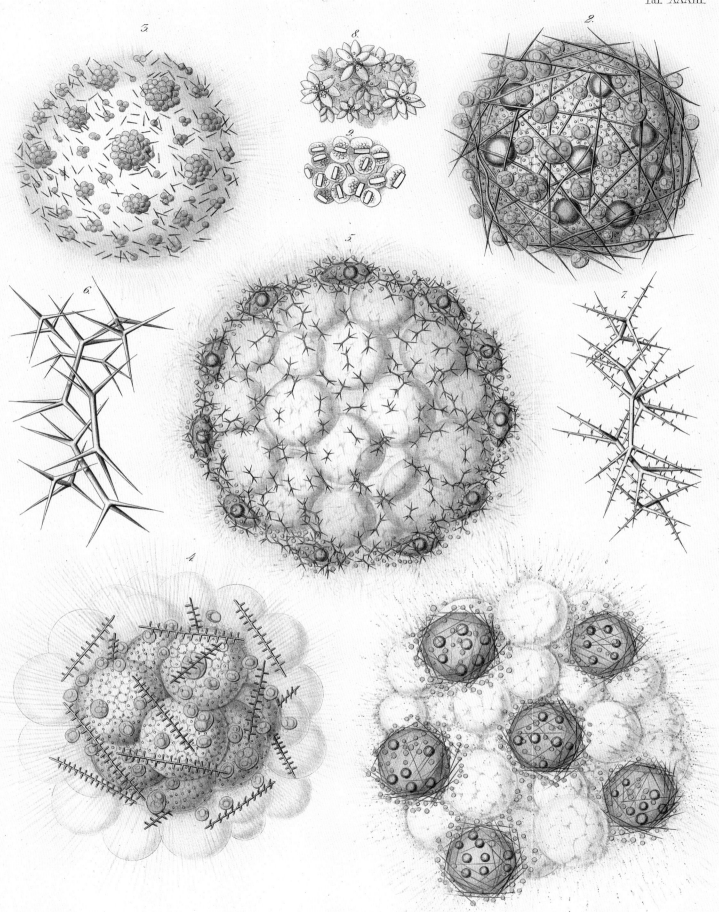

Taf. XXXIII.

1–9. Sphaerozoum. 1. 2. S. Italicum, Hkl. 3. 4. S. spinulosum, Müller.
5–6. S. Ovodimare, Hkl. 7–9. S. punctatum, Müller.

E.Haeckel del.

Wagenschieber sc.

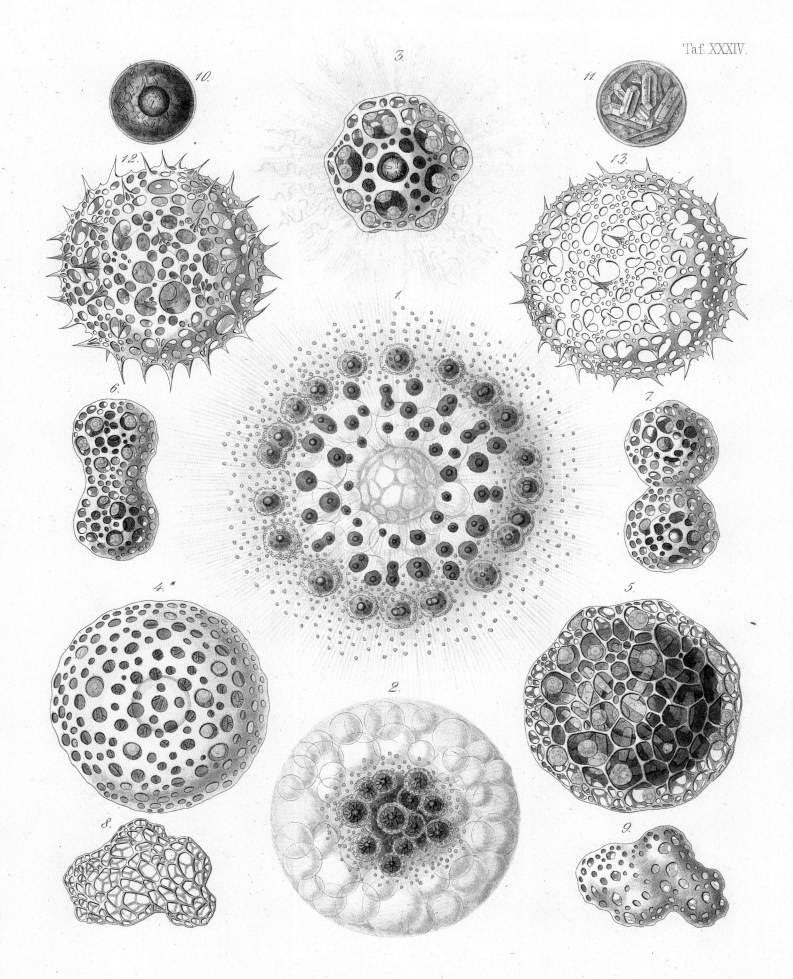

Taf. XXXIV.

1–13. Collosphaera. 1–11. C. Huxleyi, Müller. 12 13. C. spinosa, Hkl.

E. Haeckel del.

Wagenschieber sc.

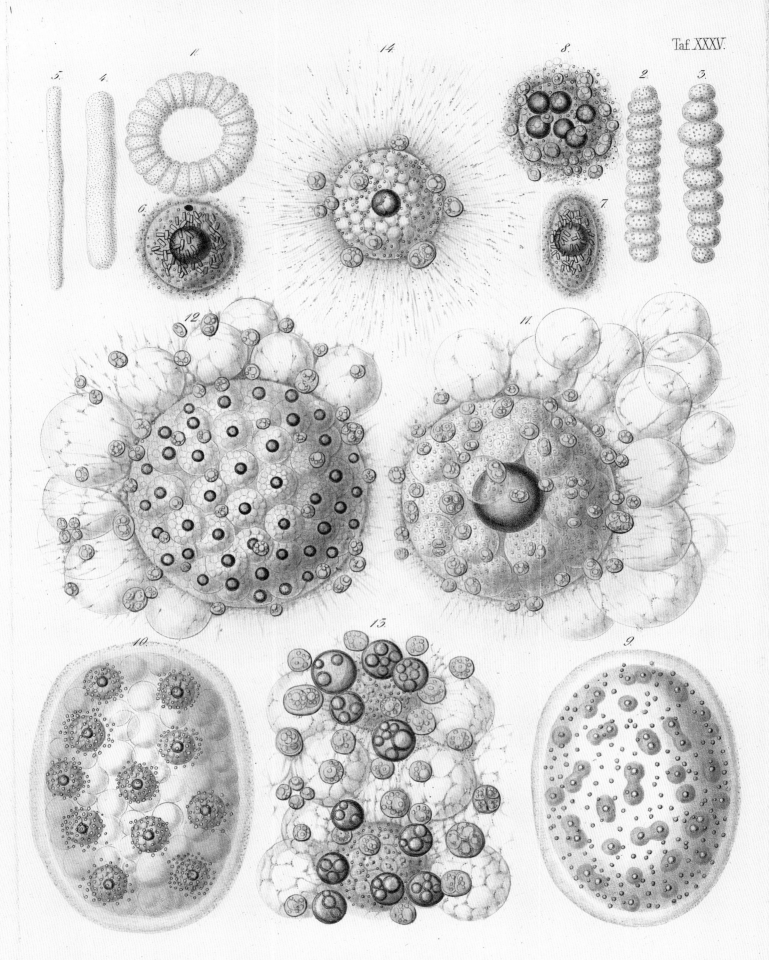

1–14. Collozoum inerme, Hkl.

E. Haeckel del.

Wagenschieber sc.

The colour plates have been reproduced from the first edition
of Haeckel's *Die Radiolarien (Rhizopoda radiaria). Eine Mono-
graphie*, Berlin 1862.
The Publisher would like to thank the Haeckel-Haus in Jena for
kindly making the original prints available for this publication.

Front cover: details from plates II, XXVII and XXXIV
Frontispiece: Ernst Haeckel with his assistant Nikolaus
Miklucho-Maclay on Lanzarote, 1866

© Prestel Verlag, Munich · Berlin · London · New York, 2005

The Library of Congress Cataloguing-in-Publication data
is available; British Library Cataloguing-in-Publication Data:
a catalogue record for this book is available from the British
Library; Deutsche Bibliothek holds a record of this publication
in the Deutsche Nationalbibliografie; detailed bibliographical
data can be found under: http://dnb.ddb.de

Prestel Verlag
Königinstrasse 9, 80539 Munich
Tel. +49 (89) 38 17 09-0; Fax +49 (89) 38 17 09-35

Prestel Publishing Ltd.
4 Bloomsbury Place, London WC1A 2QA
Tel. +44 (020) 7323-5004; Fax +44 (020) 7636-8004

Prestel Publishing
900 Broadway, Suite 603, New York, NY 10003
Tel. +1 (212) 995-2720; Fax +1 (212) 995-2733

www.prestel.com

Translated from the German by Stephen Telfer, Edinburgh
Copy-edited by Christopher Wynne

Design and production: Matthias Hauer
Typeface: Berthold *Bodoni Old Face*, G.G. Lange, 1986
Cover montage: Barbara Dezasse
Originations: Repro Ludwig, Zell am See
Printing: Passavia Druckservice, Passau
Binding: Conzella, Pfarrkirchen

Printed in Germany on acid-free paper

ISBN 3-7913-3327-5